# La Via del Carbone

# The Road to Coal

# La Route du Charbon

fotografie di Patrizia Bonanzinga

Patrizia Bonanzinga
# THE ROAD TO COAL

*photo editor/éditeur de photographies*
Roberto Salbitani

*testi/texts/textes*
Isabelle Baechler
Patrizia Bonanzinga
Paolo Longo
Roberto Salbitani

*traduzioni/translations/traductions*
Patrizia Bonanzinga, Roma
Lucian H. Comoy, Trieste
Mireille Coste, Torino
Anna Maria Farinato, Torino

*grafica di copertina/cover layout/graphisme de la couverture*
Marco Palanca

*grafica e impaginazione/page layout and design/graphisme et composition*
hopefulmonster, Torino

*fotolito/photolitography/photolithographie*
FB, Torino

*stampa/printed by/imprimerie*
Garabello Artegrafica, San Mauro Torinese

hopefulmonster editore
via Santa Chiara 30/F
10122 Torino Italy
tel +39.011.4367197
fax +39.011.4369025
www.hopefulmonster.net

Lo Shanxi è una Provincia ricca di carbone.

Oggi, in alcuni punti il paesaggio è immenso e desolato. Ma non molto tempo fa, geologicamente parlando solo quattrocento milioni di anni fa, lo stesso paesaggio era popolato da una foresta lussureggiante. Era il periodo del Carbonifero, quando la Terra era avvolta dai gas, gli alberi alti fino a sessanta metri e la Natura non aveva ancora imparato a scomporre la cellulosa. In quel periodo, un albero caduto al suolo non veniva scomposto ed ingoiato dalla Terra, ma rimaneva là ad aspettare che un altro albero gli cadesse addosso. Così si è formato il carbone.

Osservo quel paesaggio e penso alla giungla che era. Oggi, non potremmo più avere un altro Carbonifero: la Natura non può disimparare i processi appresi. Ma forse potremmo avere la stessa atmosfera irrespirabile di allora, quando avremo liberato e bruciato tutto il carbone incrostato nelle viscere della Terra.

The Province of Shanxi is rich in coal.

Today, there are some places where the landscape is vast and desolated. Yet not so long ago, geologically speaking only four hundred millions of years ago, this place was covered by a luxuriant forest. This was manifest during the Carboniferous period, when the Earth was enshrouded in gas, and covered by sixty-metre-high trees, Nature not having yet learnt how to decompose cellulose. At that time, tree a fallen was not decomposed and swalloved up by the earth, rather it stayed there waiting for another tree to fall on top of it. This led to the formation of coal.

Looking at the landscape, I cannot but imagine the jungle that existed here. Today, it is not possible to have another Carboniferous: the Nature cannot reverse what it has learnt. But maybe when all the coal in the bowels of the Earth isl released and burnt, the same unbreathable atmosphere from that period will come again.

Le Shanxi est une Province riche en charbon.

Aujourd'hui, dans certains endroits, le paysage est immense et désolé. Cependant, il y a quelques années, seulement quatre cents millions d'années d'un point de vue géologique, ce même paysage était une fôret luxuriante. C'était l'époque du Carbonifère : la Terre était entourée de gaz, les arbres mesuraient jusqu'à soixante mètres de haut et la Nature n'avait pas encore appris à décomposer la cellulose. À l'epoque, un arbre qui tombait au sol n'était pas décomposé et absorbé par la Terre, il restait là et attendait qu'un autre arbre lui tombe dessus. Couche par couche, le charbon s'est créé.

Je regarde le paysage et je pense à la jungle qui était là. Aujourd'hui, il ne peut plus y avoir de Carbonifère parce qu'on ne peut pas demander à la Nature d'oublier les processus appris. Mais peut-être, l'atmosphère sera-t-elle aussi irrespirable qu'à l'epoque, quand nous aurons libéré et brûlé tout le charbon qui est encore dans le ventre de la Terre.

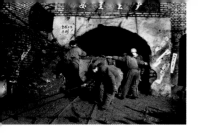

# Cina: la miniera più grande del mondo

*Paolo Longo*

La cronaca racconta che alle 8:50 di mattina di una fredda giornata d'inverno 24 minatori che lavoravano a 300 metri di profondità in una miniera di carbone nella regione autonoma dello Xinjiang Uygur, nel nordovest della Cina, sono rimasti bloccati a causa di un improvviso allagamento.

L'agenzia di stampa cinese ufficiale Xinhua riferisce così gli avvenimenti successivi: "Immediatamente dopo l'allagamento la società proprietaria della miniera ha convocato una riunione urgente per lanciare l'operazione di salvataggio che è iniziata immediatamente".

Dei 24 uomini rimasti sotto terra 15 erano bloccati nello stesso tunnel ed è lì che si sono concentrati gli sforzi. Dopo ore di lavoro i soccorsi sono arrivati a soli tre metri da loro ma un gigantesco blocco di roccia li ha fermati. "Da questa parte del tunnel sentivamo le voci sempre più deboli dei minatori, racconta uno dei soccorritori, siamo riusciti a fare arrivare loro un messaggio, restate calmi, cercate di respirare lentamente e di non fare sforzi per non consumare l'aria rimasta". I lavori sono andati avanti senza sosta e finalmente alle sei del pomeriggio i soccorritori hanno ristabilito la ventilazione nel tunnel e alle tre di mattina i 15 sono stati salvati.

Solo il giorno dopo la cronaca riporterà che nell'incidente ci sono stati sei morti.

Questa è una notizia che non manca mai nei giornali cinesi. Gli incidenti nelle miniere di carbone fanno ormai parte della vita di ogni giorno in Cina, sono l'altra faccia della medaglia del progresso e della ricchezza.

La Cina ha bisogno del carbone per muovere le sue fabbriche, per illuminare le sue città, per riscaldare le sue case, per produrre il suo acciaio. Le previsioni parlano per il 2004 di

1,7 milioni di tonnellate di carbone estratte per coprire il 70 per cento del fabbisogno energetico e ogni tentativo di migliorare la sicurezza nelle miniere e di render meno inquinante il carbone si scontra con la realtà di un paese che rischia in ogni momento una vera e propria "carestia energetica".

L'industria mineraria carbonifera cinese è la più grande del mondo, con oltre 430.000 piccole e grandi miniere, controllarle tutte è impossibile, imporre a tutte standard di sicurezza ancora di più. Il primo ministro Wen Jiabao ci ha provato, ordinando controlli a tappeto e la chiusura di migliaia di impianti, ma si è ritrovato con un drastico calo della produzione proprio mentre al contrario aumentava la domanda da parte di un'economia che continua a crescere troppo velocemente. E così un po' alla volta molte delle miniere chiuse sono state riaperte, alcune clandestinamente, e il numero degli incidenti è tornato a crescere.

La Cina combatte una battaglia decisiva per raggiungere un equilibrio tra le risorse disponibili e il tasso di crescita, prova ad allargare la scelta delle fonti energetiche utilizzate, costruisce dighe gigantesche, sogna di realizzare 19 centrali nucleari in 15 anni, punta ad accelerare l'accantonamento di riserve petrolifere strategiche e a rendere operativo al più presto un oleodotto per il gas naturale che attraverserà il paese da est a ovest; ma la dipendenza dal carbone resterà sempre molto forte, secondo tutte le previsioni il minerale coprirà all'incirca il 60 per cento del fabbisogno energetico ancora per i prossimi 50 anni.

Con un problema aggiuntivo, il costo ambientale altissimo. Il carbone è da sempre la fonte energetica fondamentale della Cina ma è negli ultimi due secoli che la sua estrazione ha raggiunto livelli industriali, e si vede. L'inquinamento oggi nelle città di questo paese è tra i più alti del mondo. L'ONU ha calcolato che l'inquinamento costa alla Cina tra il 3,8 e il 5 per cento del Prodotto Interno Lordo, mentre gli studi epidemiologici avvertono che già oggi le malattie respiratorie sono la causa del 25 per cento delle morti premature: 700.000 persone muoiono ogni anno per l'inquinamento ambientale provocato dall'uso di carbone che serve al paese per correre e alla gente per cucinare.

Insomma ancora per molto tempo la Cina dovrà scegliere tra la crescita e l'aria pulita, tra lo sviluppo e la fine degli incidenti nelle miniere.

"Troppi incidenti come quello dello Xinjiang, scriveva uno dei partecipanti a una chat, sto diventando indifferente".

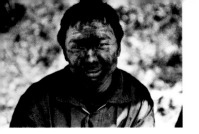

# China: the largest mine in the world

*Paolo Longo*

The news reports state that at 8.50 in the morning of a cold winter's day, 24 miners working at a depth of 300 metres in a coal mine in the autonomous region of Xinjiang Uygur, north-west China, became trapped by sudden flooding.

The official Chinese press agency, Xinhua, reported as follows on the subsequent events: "Immediately after the flooding, the company owning the mine called an urgent meeting to launch the rescue operation which began immediately."

Of the 24 men trapped below ground, 15 were in a single shaft, and it was there that the rescue efforts were concentrated. After hours of work, rescuers were just three metres from them but a gigantic mass of rock prevented further passage. "From this side of the tunnel, we heard the increasingly feeble voices of the miners", said one of the rescuers. "We managed to get a message to them: Keep calm, try to breathe slowly and move little so as not to use up the remaining air". Work went ahead without interruption and at last, at six in the afternoon, the rescuers were able to restore the ventilation in the tunnel. The 15 men were rescued at three the following morning.

Only on the following day did the news state that six miners were killed in the accident.

This sort of news forms a staple of Chinese newspapers. Accidents in coal mines are part of everyday life in China; the other side of the coin showing progress and riches.

China needs coal to make its factories work, to light up its cities, to heat its homes and produce its steel. Forecasts speak of 1.7 million tons of coal being extracted in 2004 to cover 70% of the country's energy needs. Every attempt to improve safety in the mines and make coal less polluting comes up against the reality of a country that is constantly at risk of being "energy-starved".

The Chinese coal-mining industry is the largest in the world, with over 430,000 large and small mines. It is impossible to keep checks on all of them, and imposing standards of safety even more so. Prime Minister Wen Jiabao has tried, ordering comprehensive checks and the closure of thousands of plants, but he found himself with a drastic drop in production just as demand was increasing from an economy that is still growing too fast. And so, little by little, many of the mines that had been shut down re-opened, some of them illegally, and the number of accidents has been rising again.

China is fighting a decisive battle to gain an equilibrium between the available resources and the rate of growth. It is trying to broaden the sources of energy used, by building enormous dams; it dreams of building 19 nuclear reactors in 15 years, is aiming at accelerating its storing away of strategic oil reserves and to open a gas pipeline crossing the country from east to west as quickly as possible. However, its dependence on coal is still extremely high. According to all forecasts, it will still account for about 60% of energy requirements for the next 50 years.

There is, of course, an additional problem: the extremely high environmental costs. Coal has always been a fundamental source of energy for China, but it is only in the past two centuries that its extraction has reached industrial levels, and it shows. Pollution in the country's cities today is amongst the highest on the planet. The UN has calculated that pollution costs China between 3.8% and 5% of its Gross Domestic Product. Epidemiological studies warn that respiratory diseases are already the cause of 25% of premature deaths: 700,000 people die each year because of the environmental pollution provoked by the use of coal needed by the country to work and by the people to cook.

For a long time yet, in short, China will have to choose between growth and clean air, between development and an end to accidents in mines.

"There are too many accidents like the one in Xinjiang", wrote one of the participants in a chat site; "I'm becoming indifferent to them."

## La Chine : la mine la plus grande du monde

*Paolo Longo*

L'histoire raconte qu'à 8 heures 50, par un froid matin d'hiver, 24 mineurs qui travaillaient à 300 mètres de profondeur dans une mine de charbon de la région autonome du Xinjiang Ouïgour, au nord-ouest de la Chine, sont restés piégés à cause d'une inondation improviste. L'agence de presse chinoise officielle Xinhua présente les évènements de la manière suivante : "Dès qu'elle fut avertie de l'inondation, la société propriétaire de la mine convoqua une réunion urgente afin de lancer l'opération de sauvetage qui commença immédiatement".

Sur les 24 hommes restés bloqués sous terre, 15 se trouvaient dans le même tunnel et c'est là que se sont concentrés les efforts. Après des heures de travail, les secours sont arrivés à trois mètres seulement des mineurs pris au piège mais un gigantesque bloc de roche les a arrêtés. "Dans cette partie du tunnel, nous entendions s'affaiblir les voix des mineurs, raconte l'un des membres de l'équipe de secours, et nous avons réussi à leur faire parvenir un message, restez calmes, essayez de respirer lentement et de ne pas faire d'efforts pour ne pas consommer l'air qui reste". Les travaux ont continué sans arrêt et, enfin, à six heures de l'après-midi, la ventilation dans le tunnel a pu être rétablie. A trois heures du matin, 15 hommes ont été extraits sains et saufs.

Ce n'est que le lendemain que les journaux rapporteront que 6 personnes avaient trouvé la mort dans l'accident.

Il s'agit d'une information qui ne manque jamais dans les journaux chinois. Les accidents qui ont lieu dans les mines font désormais partie de la vie quotidienne chinoise ; ils sont le revers de la médaille du progrès et de la richesse.

La Chine a besoin de charbon pour faire fonctionner ses industries, pour éclairer ses

métropoles, pour réchauffer ses habitations et produire son acier. Les prévisions parlent de 1,7 millions de tonnes de charbon extrait pour couvrir 70 pour cent des besoins d'énergie en 2004, et toute tentative d'améliorer la sécurité dans les mines et de diminuer l'impact polluant du charbon se heurte à la situation d'un pays qui risque à tous moments une véritable "famine énergétique".

L'industrie minière chinoise de charbon est la plus grande du monde, avec plus de 430.000 petites et grandes mines qu'il est impossible de contrôler dans leur totalité et auxquelles on ne peut imposer un standard de sécurité. Le premier ministre Wen Jiabao a essayé, en ordonnant des contrôles systématiques et la fermeture de milliers de structures, mais il s'est retrouvé avec une baisse très nette de la production juste au moment où la demande de la part d'une économie qui continue à croître très rapidement, augmentait. Si bien que, petit à petit, de nombreuses mines qui avaient été fermées, ont réouvert, certaines de façon clandestine, et le nombre des accidents a recommencé à augmenter.

La Chine se livre à une bataille décisive pour atteindre un équilibre entre les ressources dont elle dispose et le taux de croissance ; elle essaie d'élargir le choix des sources d'énergie qu'elle utilise, elle construit des barrages hydroélectriques gigantesques, elle rêve de réaliser 19 centrales nucléaires en 15 ans, vise à accélérer le stockage de réserves pétrolières stratégiques et à rendre le plus vite possible opérationnel un oléoduc pour le gaz naturel qui traversera le pays d'est en ouest ; mais la dépendance au charbon restera très importante, selon toutes les prévisions, le minéral couvrira environ 60 pour cent du besoin en énergie du pays encore pendant 50 ans.

Un problème s'ajoute : la très forte incidence négative sur l'environnement. Le charbon est depuis toujours la source d'énergie fondamentale de la Chine mais c'est au cours de ces deux derniers siècles que son extraction a atteint des niveaux industriels ; et cela se voit. La pollution dans les villes du pays est, aujourd'hui, parmi les plus importantes du monde.

L'ONU a calculé que la pollution coûte à la Chine entre 3,8 et 5 pour cent du Produit National Brut, alors que les études épidémiologiques avertissent qu'aujourd'hui, les maladies respiratoires sont à l'origine de 25 pour cent des morts prématurées : 700.000 personnes par an trouvent la mort à cause de la pollution de l'environnement provoquée par le charbon qui sert au pays pour soutenir son rythme de croissance et à la population pour ses besoins domestiques.

La Chine devra donc, encore pour longtemps, choisir entre croissance et air sain, entre développement et la fin des accidents dans les mines.

"Trop d'accidents comme ceux du Xinjiang, écrivait l'un des participants à une *chat*, je deviens indifférent".

# Una via dei trionfi per gli eroi del carbone

*Isabelle Baechler*

È una via che luccica.

Non è altro che polvere, frammenti neri di carbon fossile perduti dai camion e attesi al varco dai poveri sul ciglio della strada. Non è altro che una striscia di inquinamento grigiastro per terra, sui volti e sulle facciate…

No.

È anche la gloria scintillante della mica e degli sfavillii del carbone, la gloria dell'ingegnosità industriosa e millenaria della Cina: qui, da quando si sfrutta questo dono della terra, dal V secolo a. C., la via del carbone è costellata di improbabili archi di trionfo. In Cina si festeggia ancora il trionfo obsoleto dell'energia termica che tutt'oggi muove pressoché l'intera industria di un paese gigantesco, ne riscalda le gavette di operai e contadini, fa cuocere i cavoli all'aceto del Nord, bollire l'acqua dei tè sorseggiati lungo tutto l'arco della giornata, e dispensa un miliardo e trecento milioni di cinesi dal battere i denti durante il rigido inverno continentale.

Questa via che da Datong (Shanxi) conduce a Pechino è anche la somma dei coraggi, delle rassegnazioni, delle interminabili ore di fatica nel buio pesto, degli insopportabili calori sotterranei, degli scoppi di grisù traditori e mortiferi, delle volte di gallerie mal puntellate, delle infiltrazioni d'acqua che minacciano tutta la costruzione, dei vagoncini che deragliano nella loro corsa traballante.

È l'energia principale della Cina, fonte ancora di più del 70 per cento della sua potenza industriale, è il tesoro fossile della terra che ogni anno si porta via, a dir poco, tra le sette e le novemila vite in incidenti sul lavoro, senza contare la silicosi che nessuno si permette il lusso di diagnosticare…

Sono sempre gli ultimi arrivati ad essere mandati sul fondo, come quell'uomo dello Sichuan in fuga dalla sua povertà natale verso il Nord industriale, immigrato dall'interno per non ottenere troppo spesso altro che il disprezzo degli autoctoni. Le donne restano in superficie a occuparsi dei vagoncini o dei nastri trasportatori, e tra i due impegni per la miniera non rimangono mai inattive, trovano il modo di cucire suole o di sferruzzare un corredino che venderanno al mercato nel loro giorno libero. Quel tanto che basta per arrotondare il loro salario di operaie del livello più basso, quel piccolo tesoro che proteggono gelosamente, chiuso in un sacchetto di plastica.

Il carbone e i suoi splendori, le sue fierezze… il carbone e le sue scorie: la tristezza antracite dei villaggi che costeggiano la via e i loro commerci sommari.

"Stazioni di servizio" improvvisate, giusto uno sgabello sul ciglio della strada e un tubo da giardino, all'ombra di un albero. Vi si annaffiano con acqua fredda le pastiglie dei freni surriscaldate dall'interminabile discesa verso Pechino: i camion blu, stracarichi, reggono a fatica, sotto il telone i sostegni sono stati adattati alla bell'e meglio per aggiungere una tonnellata o due del prezioso carico.

Le vere stazioni di servizio statali assomigliano vagamente a un tempio thai, quando sono recenti, o a vecchi rottami di sputnik scoloriti quando risalgono agli anni Ottanta, ma sono sempre magniloquenti e sovradimensionate, sempre ricoperte da una coltre di polvere grassa.

Le bettole, tutte grigie, sono rallegrate da un poster con ananas e palme di celluloide per ridare ai camionisti esausti la forza di tornare al lavoro; a volte una brandina in un angolo permette loro di eliminare l'eccesso di fatica, dopo aver tracannato la zuppa di vermicelli; a volte è una stanza sul retro, dove una prostituta li libererà dalle tensioni più impellenti…

Qui tutto è tra il grigio e il nero, con una predominanza dell'antracite, a cominciare dal telo bianco (!) che divide la sala da pranzo dalla cucina.

Abbiamo voluto seguire il carbone fino a destinazione: le bricchette, mattonelle rotonde bucherellate per il tiraggio, nelle stufe dei vecchi pechinesi, quelle che ancora si trasportano a mano sul pianale dei tricicli, o a spalla, quelle che le officine statali hanno compattato nei quartieri della capitale: polvere e acqua come legante, poi una pressa per dare alla bricchetta di carbone la sua rotondità finale. Le bricchette sono così piene di impurità che escono dalle stufe intatte, solamente rosa-giallognole anziché nere come il carbone, per l'appunto: terra cotta che durante la combustione avrà prodotto calore e inquinamento in abbondanza. In Cina si muore molto di malattie polmonari causate dai fumi inalati nell'isolamento delle case chiuse quasi ermeticamente!

Perché è l'onnipresente carbone che dà al Nord della Cina quell'odore così particolare che prende alla gola il visitatore all'uscita dell'aeroporto… Quell'olezzo acre e grasso che impregna l'aria, quella polvere impietosa che si deposita ovunque, che ingrigisce e corrode i Buddha scolpiti di Datong, che buttera le facciate a Pechino e altrove. Il carbone trionfante, da cui l'economia cinese non può prescindere e che sfrutterà fino alla fine. Quel carbone fossile che lo stato tenta ora di sfruttare in modo meno sporco, con le tecniche occidentali del letto fluido per liberarlo dall'eccesso di zolfo. A volte, per alleggerirsi la coscienza, ci si limita a lavarlo con un bel po' d'acqua, all'uscita dalla miniera… ma le piogge acide, trasportate verso est dai venti dominanti, decimano le foreste coreane e giapponesi.

Ma non fa niente: il carbone "pulito" è troppo caro per la Cina che deve sostenere il ritmo infernale di una crescita economica dell'8 per cento annuo. Non c'è tempo per cercare un combustibile alternativo: bisogna fare in fretta, e il meglio è nemico del bene. E nondimeno, la rete ferroviaria di tutto l'Est del paese è satura, occupata com'è per quasi il 60 per cento dal trasporto del carbone dai luoghi di estrazione alle aree industriali. Le scuole dei villaggi e una gran parte degli immobili cittadini si riscalderanno con grossi pezzi di carbone grezzo ancora per molti anni: caldaie monumentali continueranno a inghiottire golosamente queste gemme gigantesche, i cortili sul retro delle case popolari e degli uffici amministrativi avranno per tutto l'anno il loro bel mucchio di carbone dalla geometria variabile e le tracce nerastre che l'accompagnano, i comignoli starnutiranno sempre il loro moccio grigio e contribuiranno in larga misura al tasso di diossido di zolfo che preoccupa gli scienziati e gli ecologisti di tutto il mondo.

Ciò nondimeno, la normativa si aggiorna, tant'è che nella capitale è ormai obbligatorio installare nelle nuove costruzioni il riscaldamento a gas naturale, e le stufe a bricchette hanno i giorni contati. Fra un centinaio d'anni, quando le riserve di carbone saranno ormai prossime all'esaurimento, le glorie dei gloriosi minatori di fondo non saranno altro che scorie della Storia. Se ne evocherà la dedizione come un eroismo fossile, accantonato tra i fasti della Lunga Marcia e le imprese trionfali della classe operaia.

# A triumphal way for the heroes of coal

*Isabelle Baechler*

It is a road that sparkles.

It is nothing other than dust, black fragments of fossil carbon falling off lorries and awaited by the poor by the edge of the road. It is nothing other than a band of greyish pollution on the ground, on faces and façades…

No.

It is also the scintillating glory of mica and the glitter of coal, the glory of the industrious, thousand-year-old ingeniousness of China: here, since this gift from the earth has been exploited, since the 5th century B.C., the coal road has been dotted with improbable triumphal arches.

The obsolete triumph of the thermal energy that still moves almost all this gigantic country's industry is still celebrated in China; it heats the mess tins of workers and peasants, cooks the cabbages in vinegar of the North, boils the water for tea sipped throughout the day, and saves 1.3 billion Chinese from chattering teeth during the freezing continental winter.

This road that leads from Datong (Shangshui) to Beijing is also the sum of courage, resignation, interminable hours of hard work in pitch darkness, unbearable subterranean heat, explosions of lurking, deadly firedamp, of tunnels that have never been propped, of infiltration of water threatening the entire construction, of little wagons that derail as they follow their trundling course.

Coal still constitutes China's main source of energy, is the source of more than 70% of its industrial capacity and is the fossil treasure of the earth. Every year, it takes in tribute 7,000 to 9,000 lives in accidents at work, without mentioning the silicosis that nobody bothers to diagnose…

It is always the recent arrivals who are sent to the bottom, such as the man escaping from the poverty of his birthplace in Shich'uan and heading for the industrial north; an internal emigrant who all too frequently gains nothing but contempt from the locals. The women remain above ground and handle the trolleys or conveyor belts. They are never inactive between these tasks for they find a way to sew soles or knit some knick-knacks to be sold in the market on their day off. Just enough to round off their salary at the lowest level set for workers, and which they jealously save in a little plastic bag. Coal and its splendours, its mettle… coal and its waste: the anthracite-coloured misery of the villages along the road and their basic shops.

There are improvised "service stations": a trestle by the side of the road with a garden hose in the shade of a tree. They sprinkle cold water on the over-heated brake pads on the interminable descent towards Beijing; the heavily-loaded blue lorries barely make it, as beneath the tarpaulin the supports have been adapted in an shoddy manner so as to add a ton or two of precious cargo.

The real state-run service stations vaguely resemble a Thai temple (if they are recent) or discoloured sputnik wrecks (if they date from the eighties), but they are always grandiose and oversize, and always covered with a coating of greasy dust.

The inns – all of them grey – are decorated with a poster of pineapples and plastic palm trees to give the exhausted drivers the strength to go back to work; sometimes, a camp-bed in a corner enables them to shed some of their tiredness after gulping down their noodle soup; sometimes, there is a room at the back where a prostitute will relieve them of some of the worst of their tension… Here everything ranges from grey to black, with a prevalence of anthracite, starting with the white (!) canvas screen separating dining room from kitchen.

We wanted to follow the coal all the way to its destination: the briquettes, round, pitted lumps holed to facilitate a draught, disappearing into the stoves of old residents of Beijing. They are still carried by hand on the back of tricycles, or on men's shoulders; they are compacted by state factories in various quarters of the capital; dust with water as a binding, then compression to give the briquette its final round shape. These briquettes are so full of impurities that they come out of the stoves intact, but only pinkish-yellow instead of coal-black: a concoction that during combustion has produced heat and pollution in equal abundance. In China, a lot of people die from lung diseases caused by inhaling fumes in houses that have been almost hermetically sealed!

It is coal that gives the north of China that special smell that grabs you by the throat as soon as you come out of the airport… That acrid, greasy stink that fills the air, that merciless dust that settles everywhere, that eats into the Datong Buddhas and makes them grey, that pock-marks façades in Beijing and elsewhere. All-triumphant coal, without which the Chinese economy cannot go on and which will be used to the end. That fossil coal that the state is now trying to exploit in a less dirty way, using the Western techniques of a fluid bed to free it of excess sulphur. Sometimes, to lighten their conscience, it is simply washed down with water when it comes out of the mine… but the acid rains, carried east by the predominant winds, are decimating the Korean and Japanese forests.

But so what: "clean" coal is too expensive for a China that has to sustain a headlong economic growth of 8% per annum. There is no time to look for alternative combustibles: there is no time, and looking before leaping is no solution. And yet, the railway network of the whole of the east of the country is saturated, 60% of all traffic being devoted to transporting coal from where it is extracted to the industrial areas. The village schools and a good part of city buildings will be heated with large lumps of raw coal for a long while yet: monumental boilers will continue to swallow these huge gems, and the courtyards behind poor houses and administrative offices will for years have their varying heaps of coal and the black stains that are their concomitant feature. The chimney pots will continue to sneeze out their grey snot and will largely account for the levels of sulphur dioxide that is so worrying scientists and ecologists throughout the world.

Nevertheless, the regulations are being revised, and in the capital it is now obligatory to install natural gas heating in new buildings, so the stoves and their briquettes are approaching the end of their lives. In a hundred years or so, when coal reserves will be close to exhaustion, the glories of the glorious bottom-level miners will be nothing more than the dregs of history. Their dedication will be recalled as a fossil heroism, to be archived alongside the annals of the Long March and the triumphal achievements of the working classes.

# Une route des triomphes pour les héros du charbon

*Isabelle Baechler*

C'est une route qui scintille.

Elle n'est pas que poussier, fragments noirs de houille perdus par les camions et guettés par les pauvres sur le bas-côté. Elle n'est pas que traînée de pollution grisâtre par terre, sur les faces et les façades…

Non.

Elle est aussi gloire scintillante du mica et des éclats de charbon, gloire de l'ingéniosité industrieuse et millénaire de la Chine : depuis qu'on exploite ce cadeau de la terre ici, depuis le 5ème siècle avant notre ère, la route du charbon est jalonnée d'arcs de triomphe improbables.

On célèbre encore en Chine le triomphe obsolète de l'énergie thermique qui meut pourtant encore presque toute l'industrie d'un pays gigantesque, qui en réchauffe toutes les gamelles ouvrières et paysannes, qui fait sauter les choux au vinaigre du Nord, fait bouillir l'eau des thés qu'on sirote à longueur de journée et empêche de grelotter un milliard trois cents millions de Chinois pendant le rude hiver continental.

Cette route de Datong (Shanxi) à Pékin est aussi la somme des courages, des résignations, des heures interminables de labeur dans l'obscurité, des insoutenables chaleurs souterraines, des coups de grisou traîtres et meurtriers, des ciels de galeries mal étayés, des infiltrations d'eau qui menacent tout l'édifice, des wagonnets qui déraillent dans leur course brinquebalante.

C'est l'énergie primaire de la Chine, encore source de plus de 70 pour cent de sa puissance industrielle, c'est le trésor fossile de la terre qui ravit 7 à 9000 vies par accident chaque année au bas mot, sans compter les silicoses que personne ne s'offre le luxe de dépister…

Ce sont toujours les derniers arrivés qu'on envoie au fond, comme ce Sichuanais fuyant sa pauvreté natale vers le Nord industriel, immigré de l'intérieur qui ne récolte trop souvent que le mépris des autochtones. Les femmes restent en surface pour gérer les wagonnets ou les tapis roulants, jamais inactives entre deux tâches minières, elles trouvent le moyen de coudre des semelles ou de tricoter de la layette qu'elles iront vendre au marché leur jour de repos. Juste de quoi améliorer un peu leur ordinaire d'ouvrières du bas de l'échelle, le petit trésor qu'elles protègent jalousement à l'abri d'un sac plastique.

Le charbon et ses brillances, ses fiertés… le charbon et ses scories : la tristesse anthracite des villages qui bordent la route et leurs commerces sommaires.

Des "stations service" improvisées se réduisent à un tabouret sur le bas côté de la route et un tuyau d'arrosage, à l'ombre d'un arbre. On y asperge d'eau froide les plaquettes de frein qui ont trop chauffé dans l'interminable descente vers Pékin : les camions bleus surchargés peinent car sous la bâche, leurs montants ont été bricolés pour ajouter une tonne ou deux de précieux chargement.

Les vraies stations services d'état ont de faux airs de temples thaï quand elles sont récentes, ou de vieux restes de spoutniks décatis quand elles datent des années 80, mais sont toujours grandiloquentes et surdimensionnées, mais toujours ternies par une pellicule de poussière grasse.

Les gargotes toutes grises égayées d'un poster aux ananas et palmiers celluloïd pour redonner du cœur à l'ouvrage aux routiers exténués, souvent un lit de camp dans un coin leur permet d'éliminer un trop-plein de fatigue après avoir lampé leur soupe de nouilles, quand ce n'est pas une back-room où une prostituée les délivrera des tensions les plus impérieuses… Tout y est de gris à noir, avec une prédilection pour l'anthracite, à commencer par le drap blanc (!) qui sépare la salle à manger de la cuisine.

Nous avons voulu suivre le charbon jusqu'à sa destination : les briquettes rondes trouées

pour le tirage dans le poêle des vieux Pékinois, celles qu'on livre encore sur la plate-forme des vélos-triporteurs, à la main, à dos d'homme, celles que les usines d'état ont compactées dans les quartiers de la capitale : du poussier et de l'eau pour le liant, puis une presse qui donne à la galette de charbon sa rondeur finale. Ces briquettes sont tellement pleines d'impuretés qu'elles sortent du poêle intactes, simplement rose-jaunâtres au lieu d'être noir de jais : terre cuite qui aura chauffé et abondamment pollué pendant sa combustion. On meurt beaucoup en Chine de maladies pulmonaires dues aux fumées inhalées dans le vase clos des maisons calfeutrées !

Car c'est le charbon omniprésent qui donne au Nord de la Chine ce parfum si particulier qui saisit le visiteur à la gorge au sortir de l'aéroport… Cette odeur âcre et grasse qui habite l'air, cette poussière impitoyable qui se dépose partout, qui grisaille et ronge les Bouddhas sculptés de Datong, qui vérole les façades de Pékin et d'ailleurs. Le charbon triomphant, dont l'économie chinoise ne peut se passer et qu'elle exploitera jusqu'à son extinction. Cette houille que l'état tente désormais d'exploiter de manière moins sale, avec les techniques occidentales de lit fluidifié pour la débarrasser de son excès de soufre. Parfois on le lave seulement à grande eau au sortir de la mine pour se donner bonne conscience… mais les pluies acides, transportées vers l'Est par les vents dominants, déciment les forêts coréennes et japonaises.

Mais rien n'y fait : le charbon "propre" est trop cher pour la Chine qui doit soutenir le rythme infernal d'une croissance économique de 8 pour cent par an. Pas le temps de chercher de combustible alternatif : il faut faire vite et le mieux est l'ennemi du bien. Et pourtant, le réseau ferroviaire de tout l'Est du pays est saturé, occupé qu'il est à près de 60 pour cent par le transport du charbon des lieux d'extraction jusqu'aux sites industriels. Les écoles de village et une majorité d'immeubles urbains se chaufferont à l'aide de gros morceaux de charbon bruts pendant de longues années encore : des chaudières monumentales continueront d'avaler goulûment ces gemmes géantes, les arrières-cours des HLM et des administrations abriteront tout au long de l'année leur tas de charbon à géométrie variable et les traînées noires qui l'accompagnent, les cheminées cracheront toujours leur morve grise et contribueront largement au taux de dioxyde de souffre qui préoccupe les scientifiques et les écologistes du monde entier.

Les règlements évoluent, cependant, puisque dans la capitale, il est désormais obligatoire d'installer le chauffage au gaz naturel dans les nouvelles constructions et que les jours des poêles à briquettes sont comptés. Dans une centaine d'années, quand les ressources houillères seront près de s'épuiser, les gloires des mineurs de fond méritants ne seront plus que scories de l'Histoire. On évoquera leur dévouement comme un héroïsme fossile, remisé entre les fastes de la Longue Marche et les exploits de la classe ouvrière triomphante.

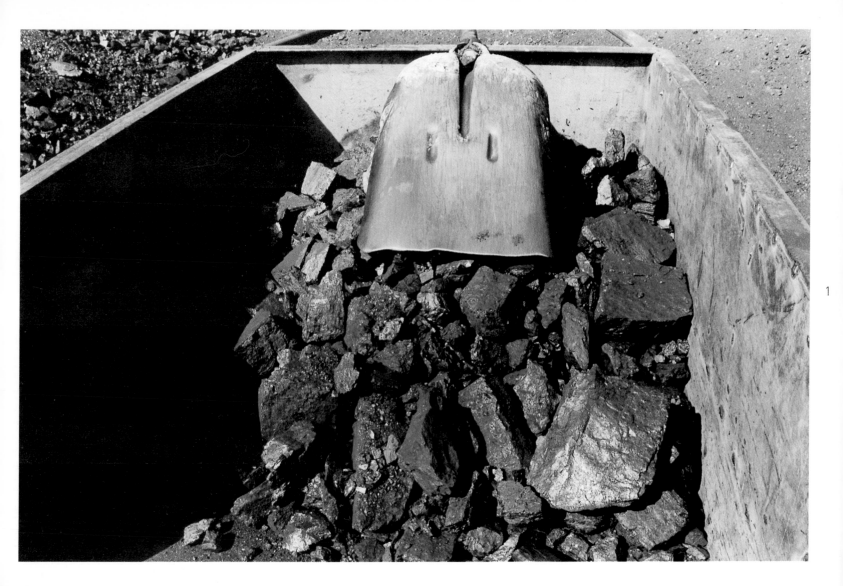

2

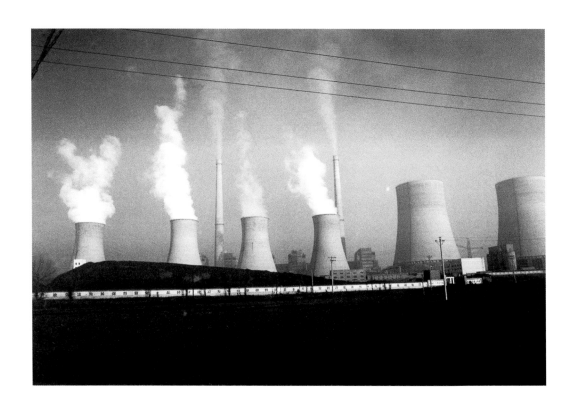

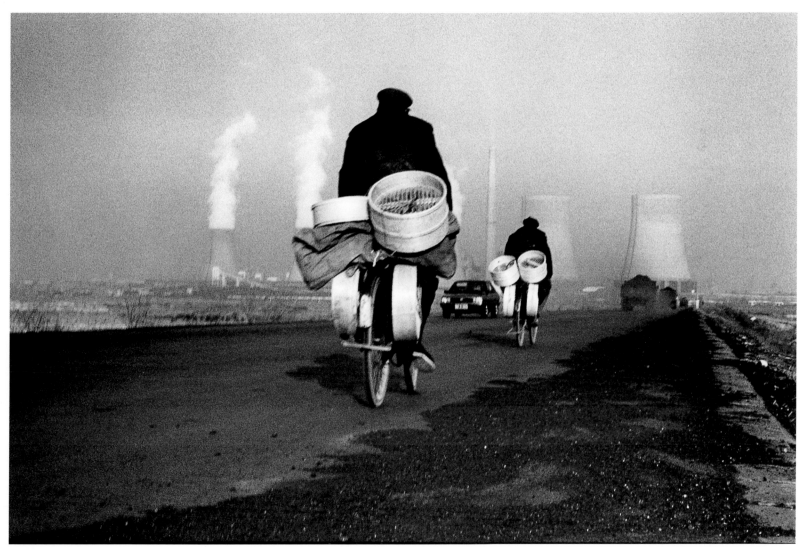

4

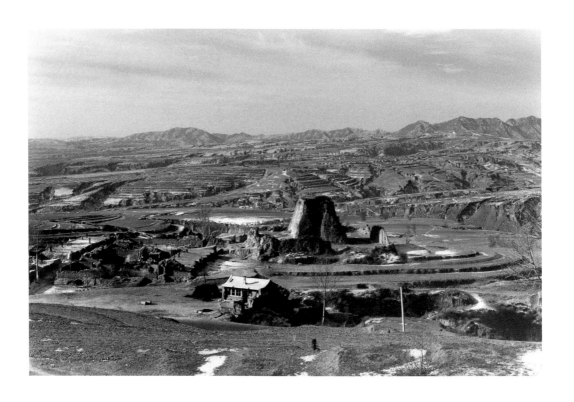

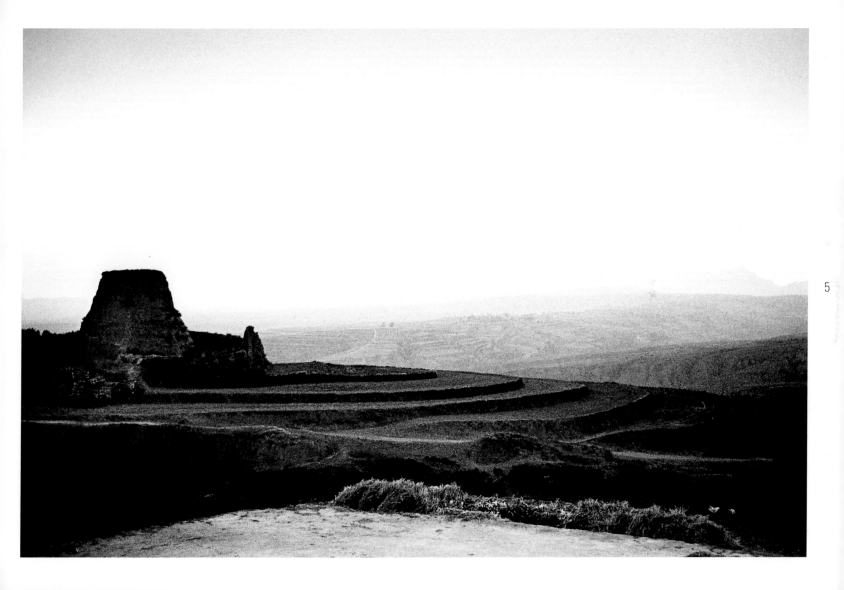

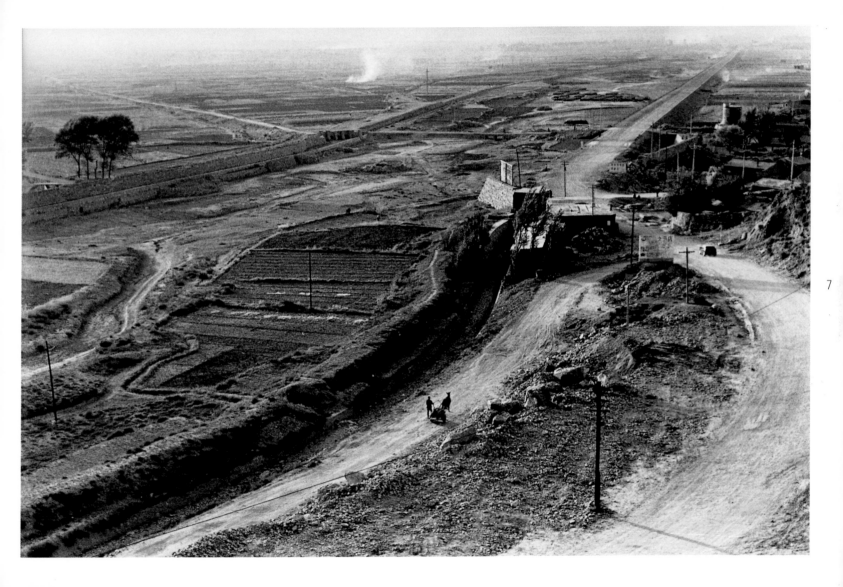

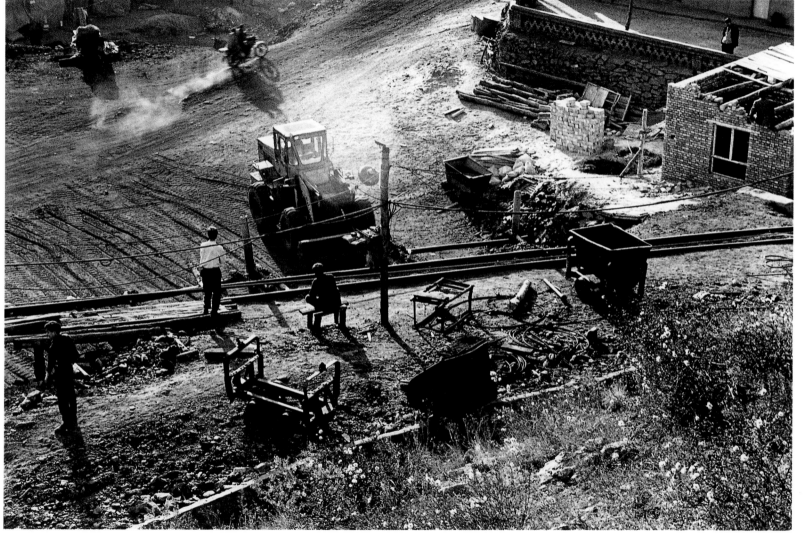

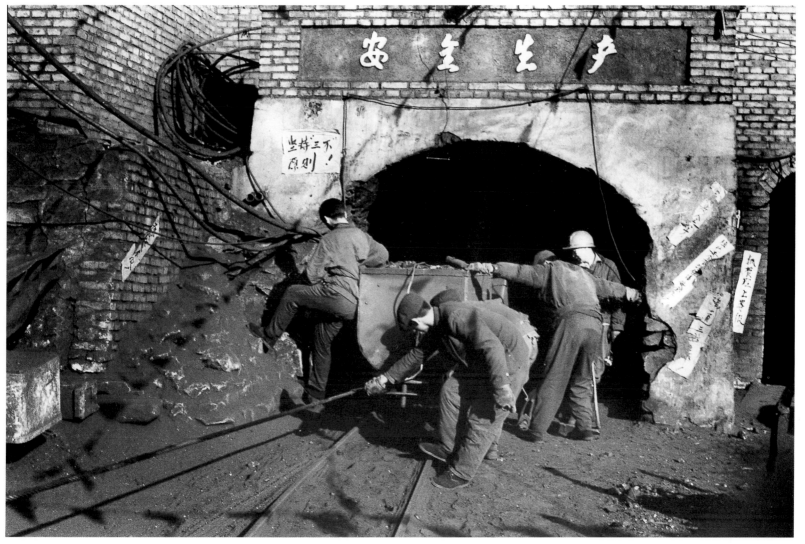

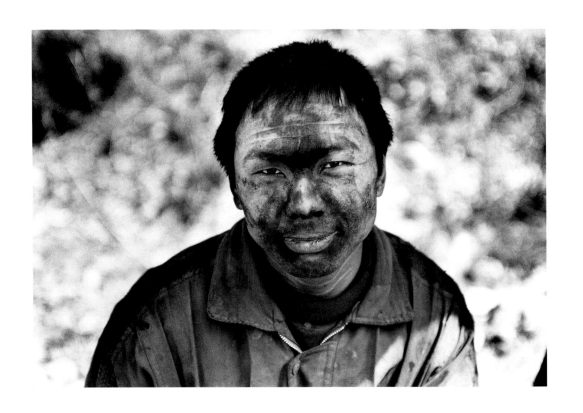

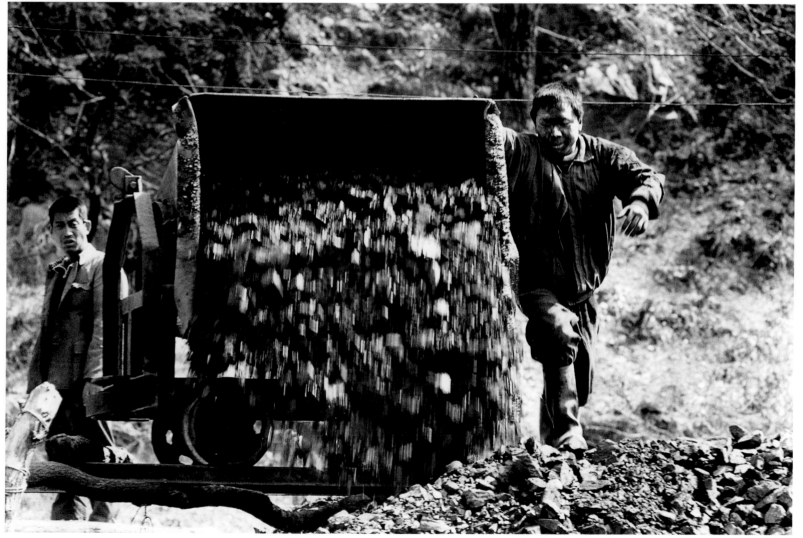

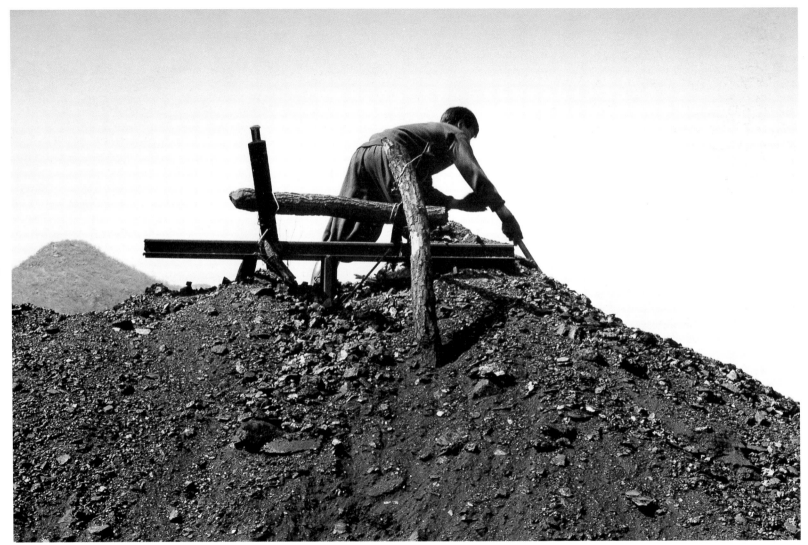

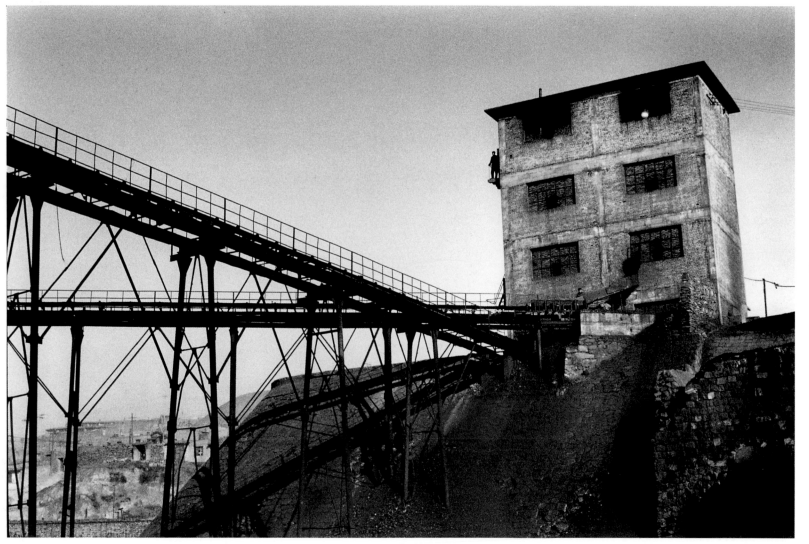

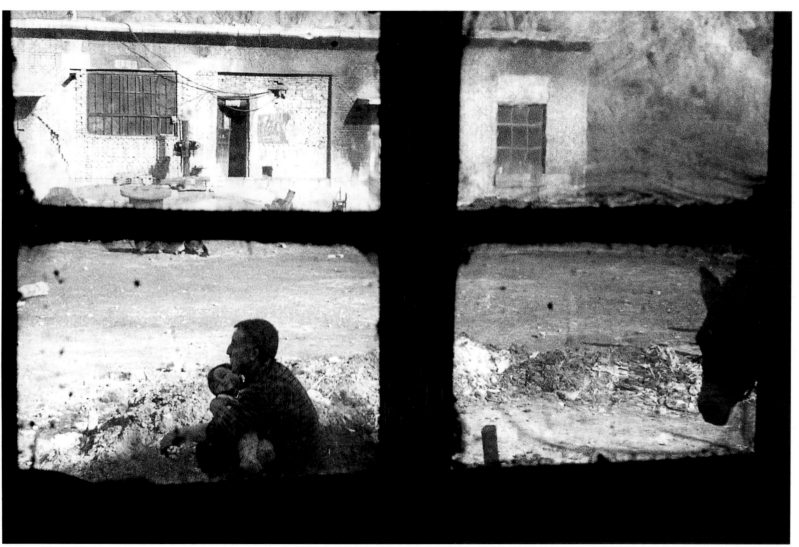

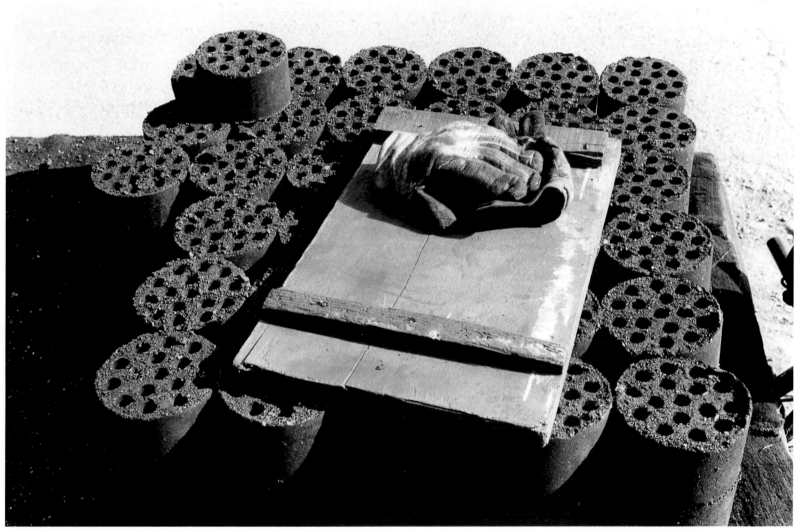

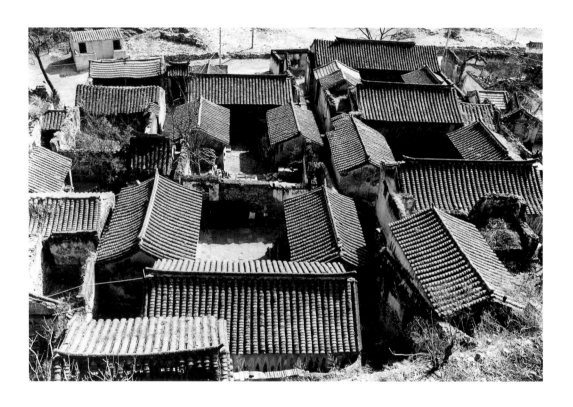

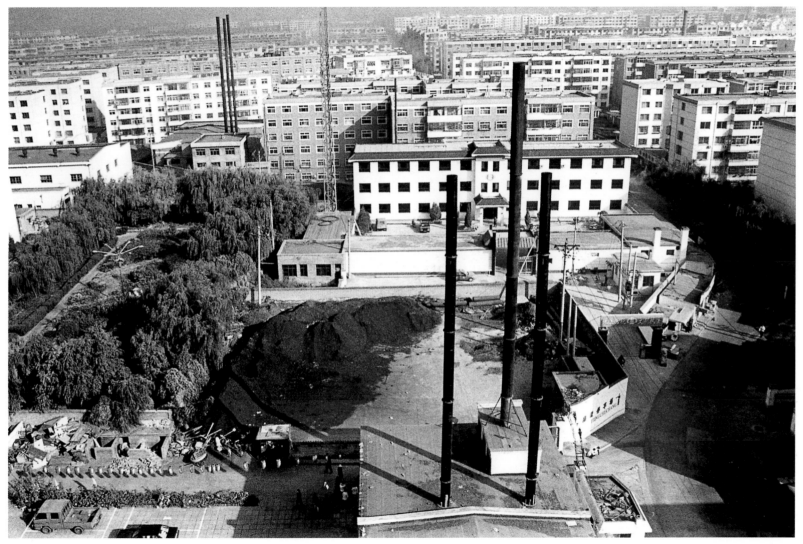

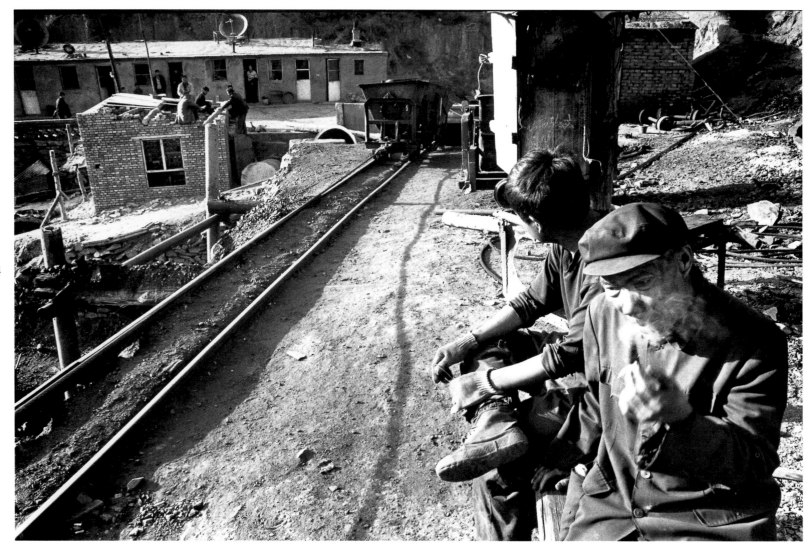

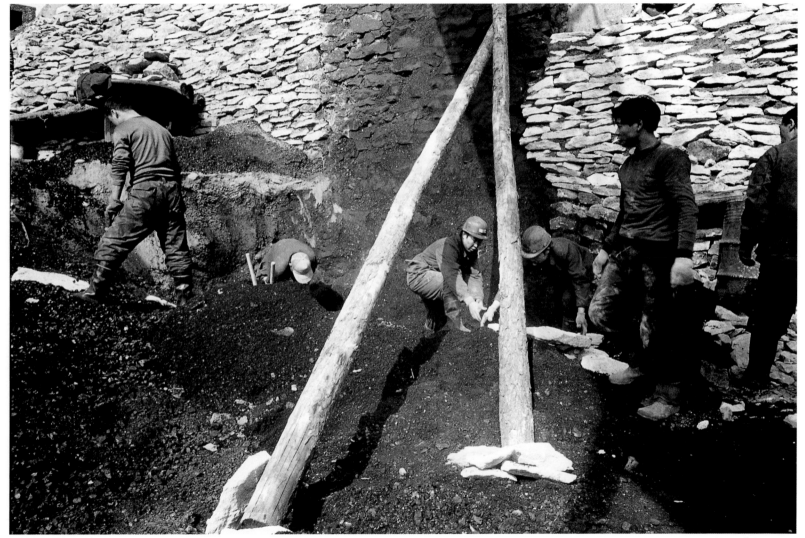

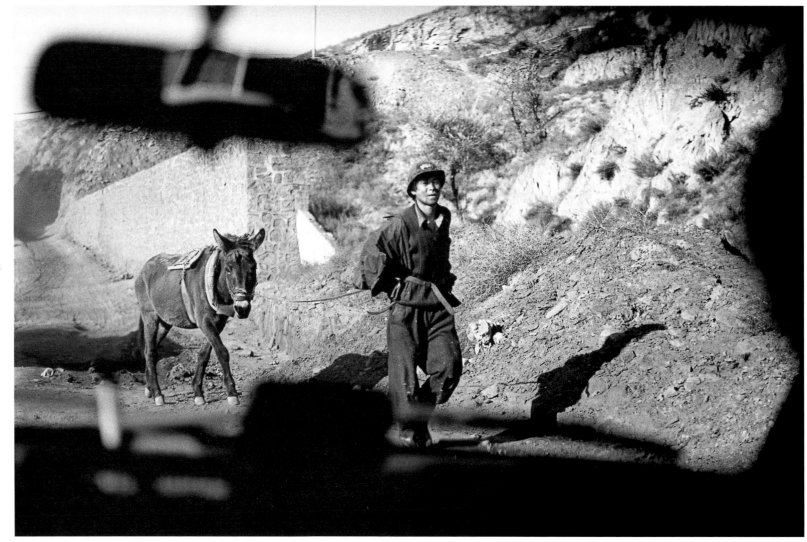

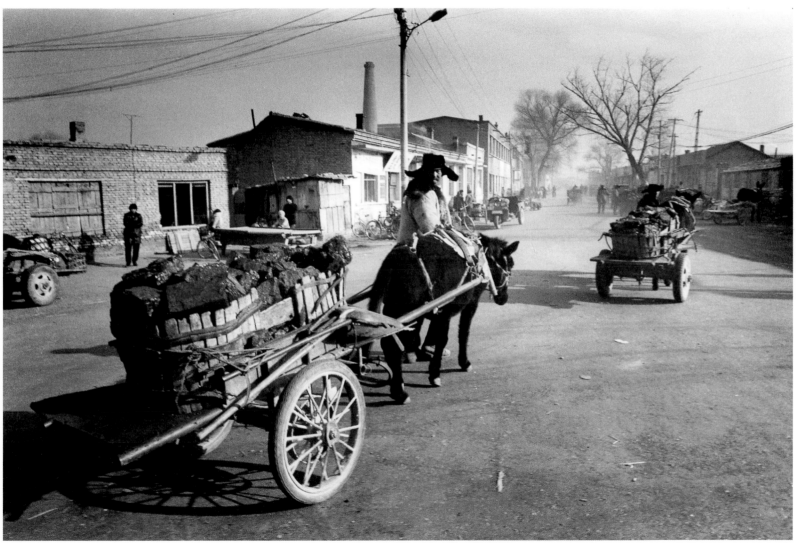

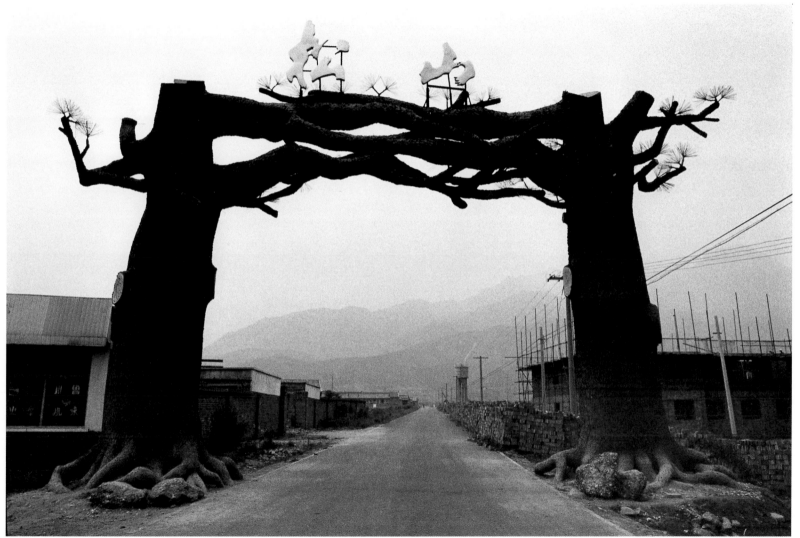

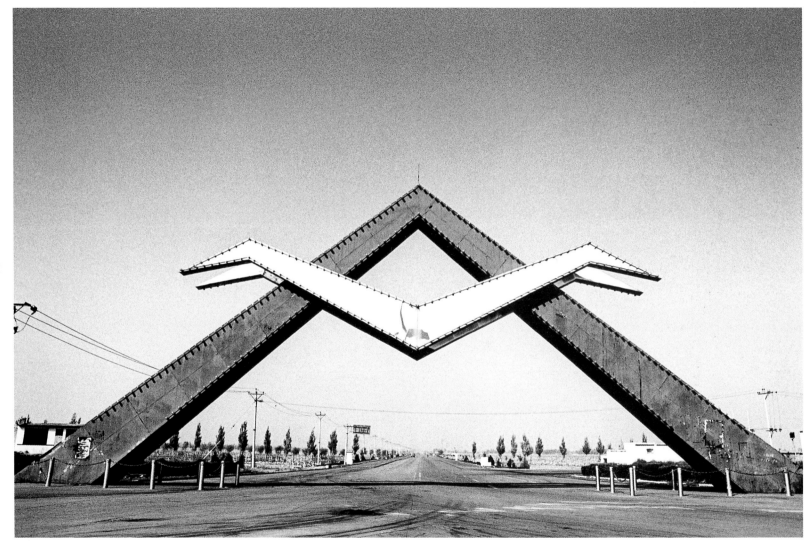

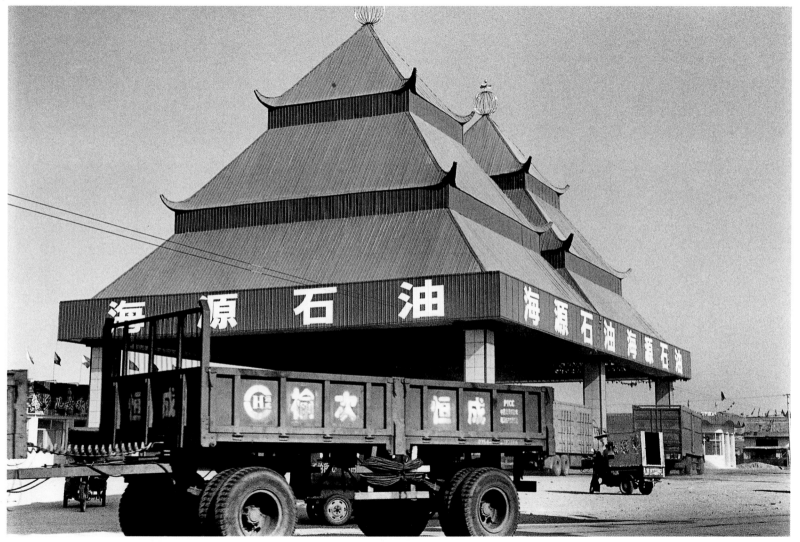

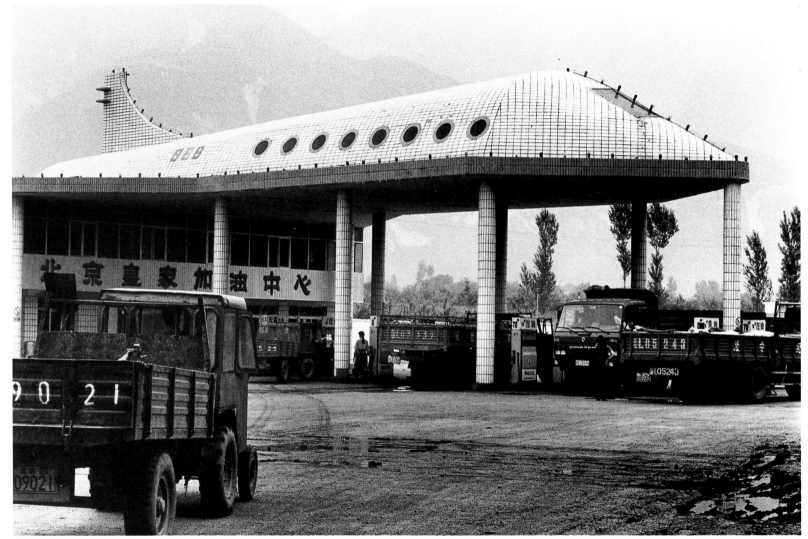

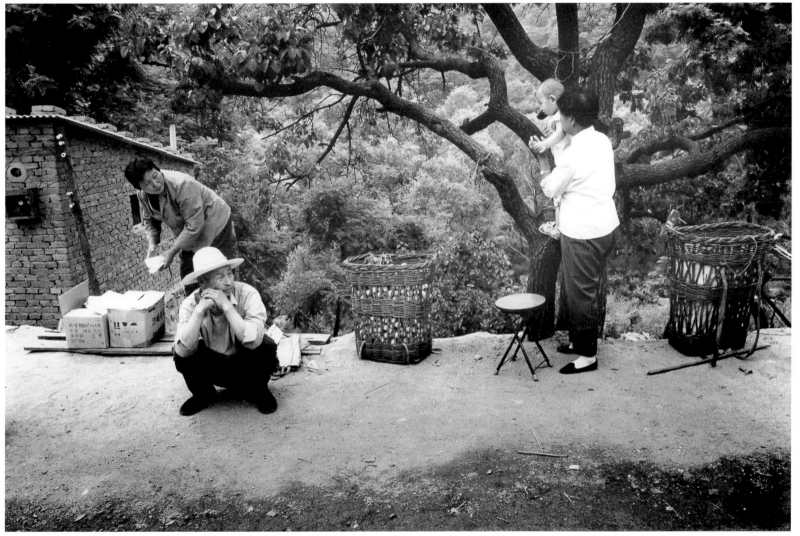

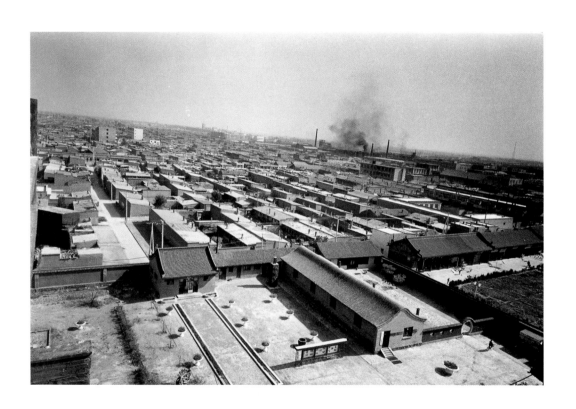

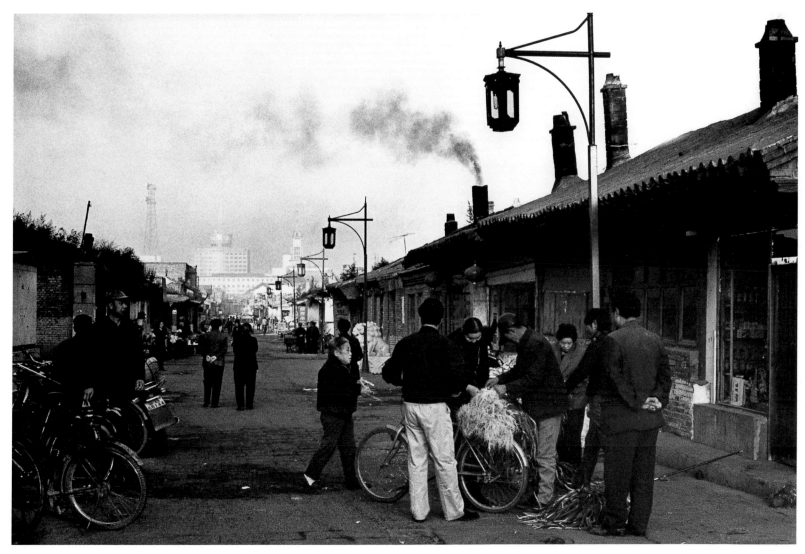

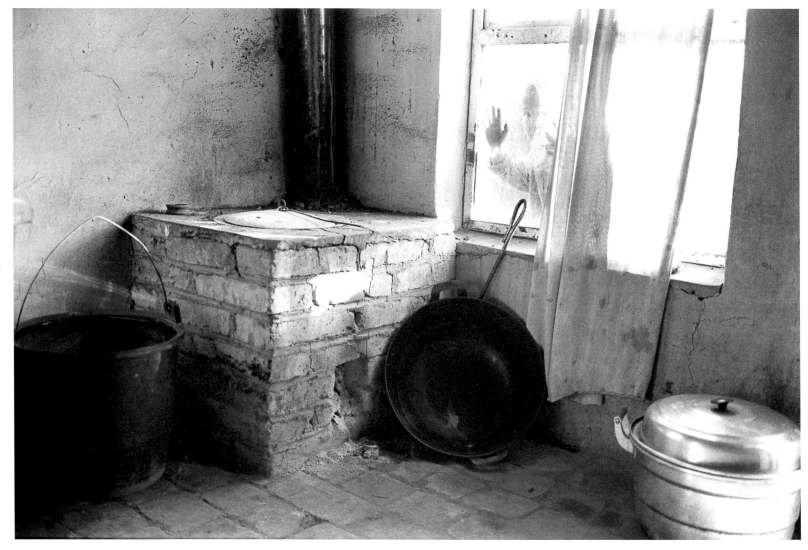

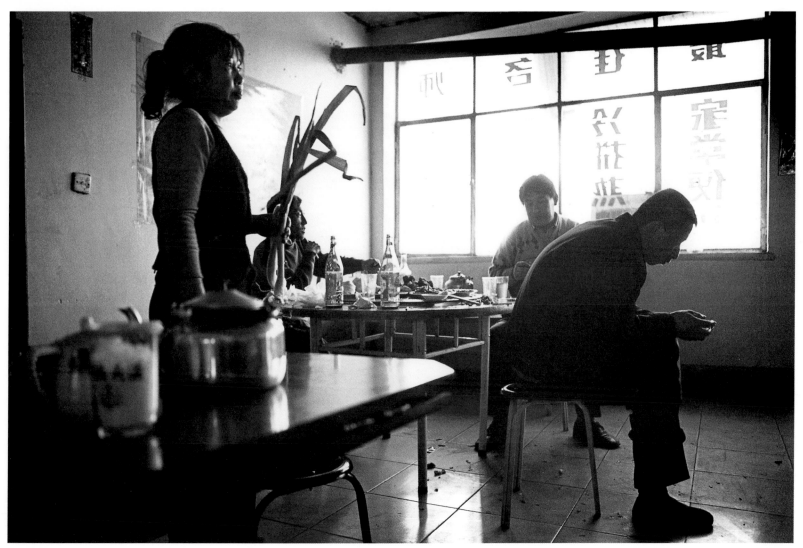

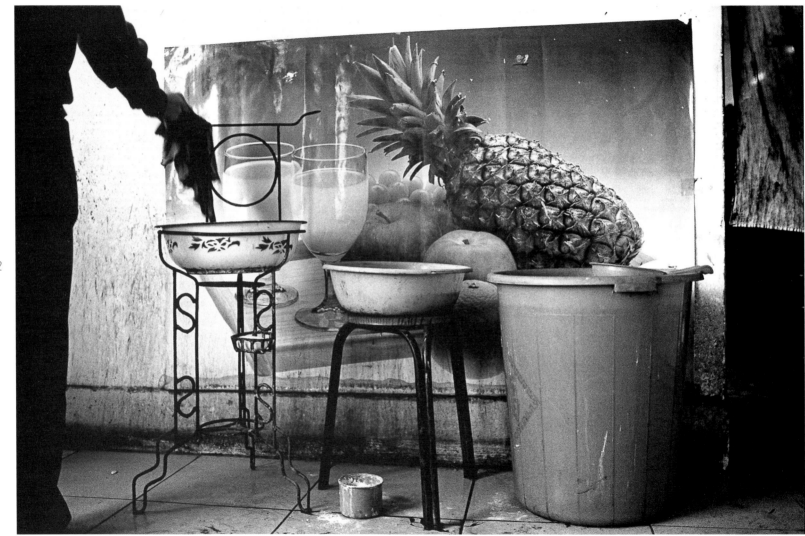

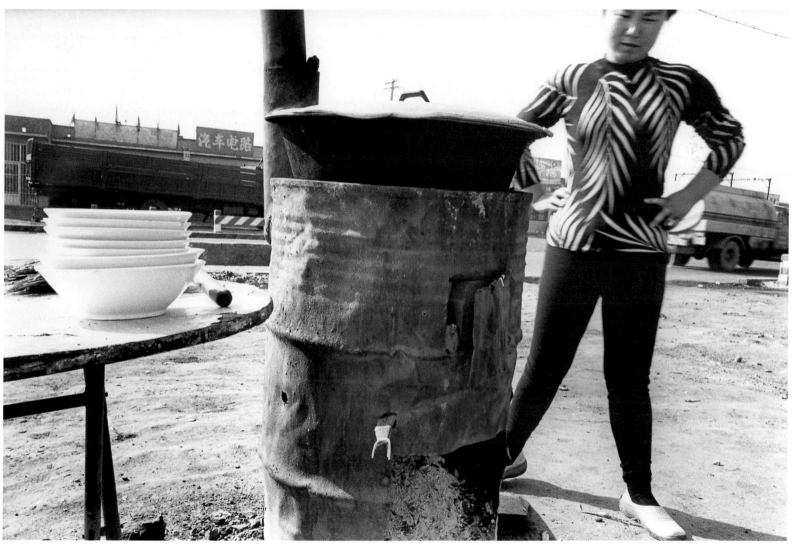

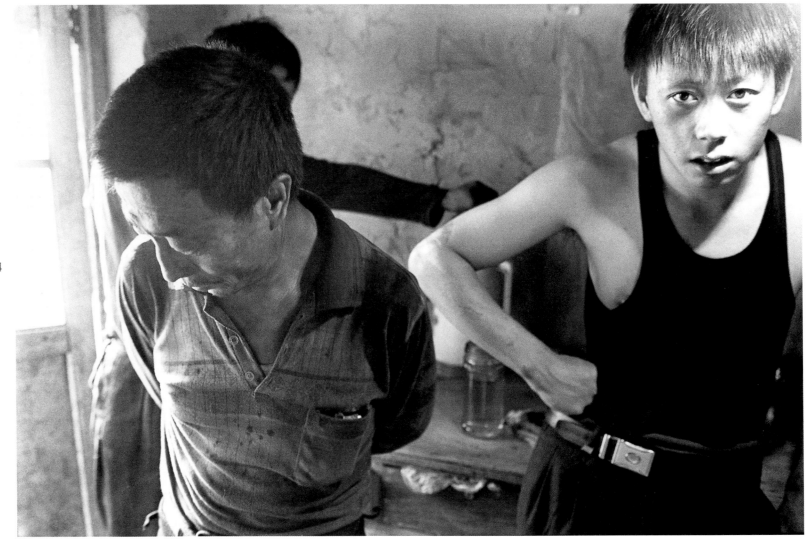

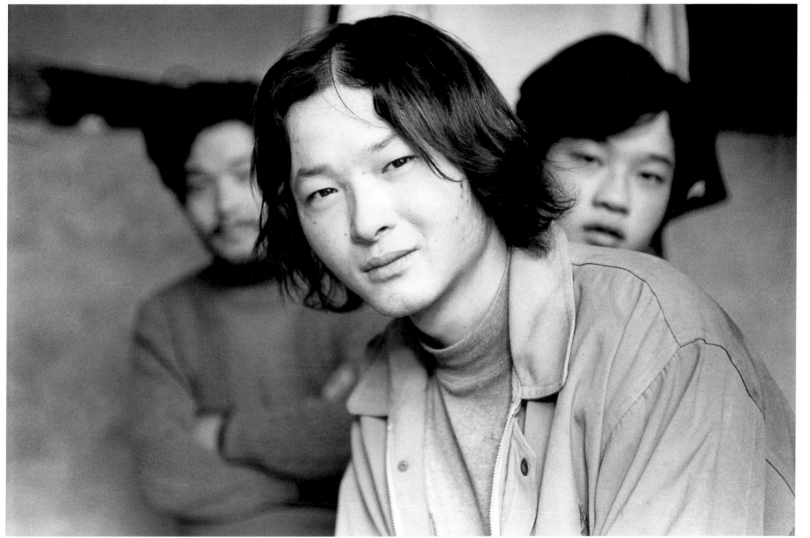

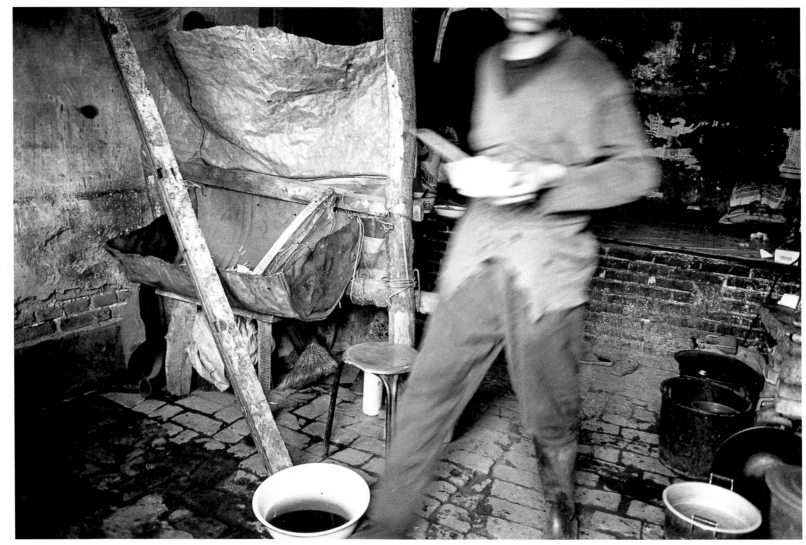

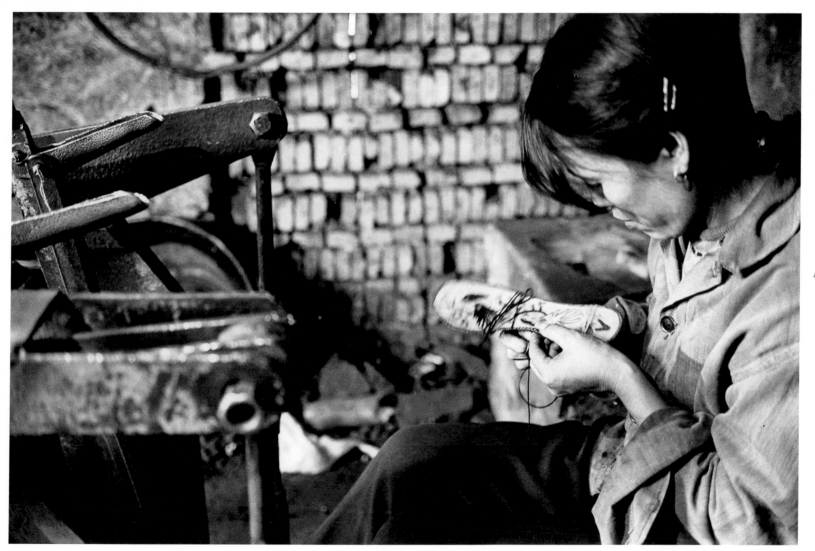

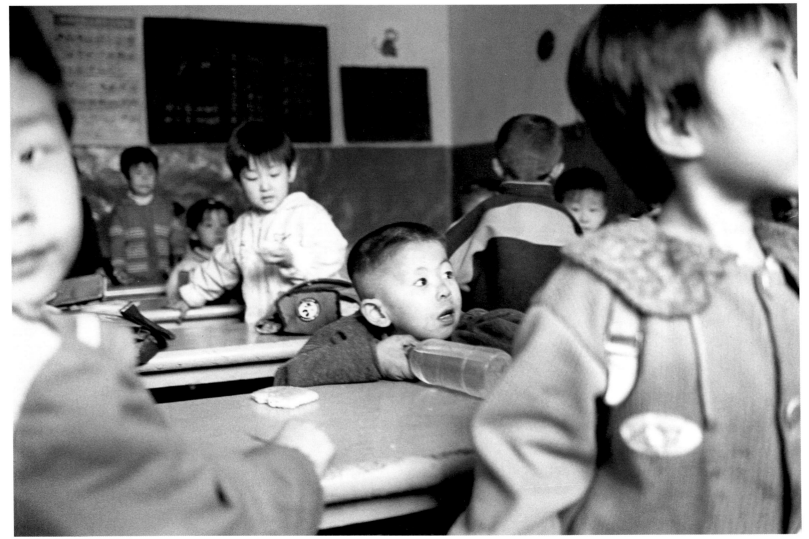

48

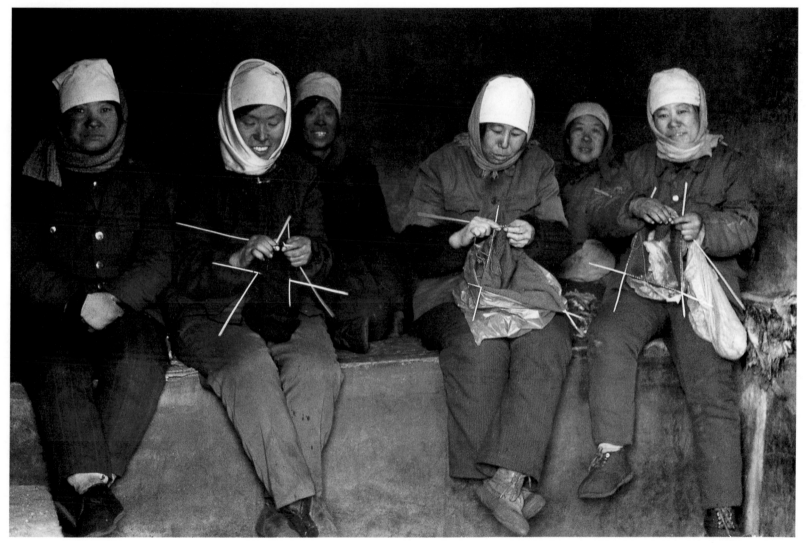

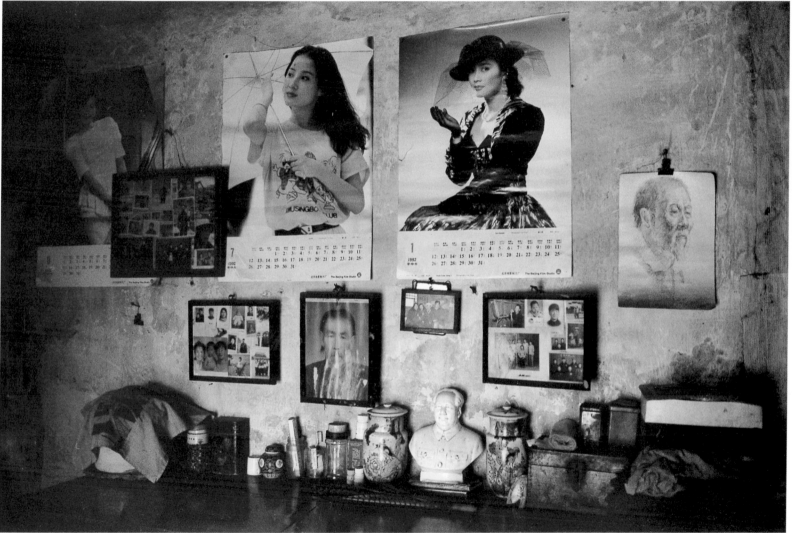

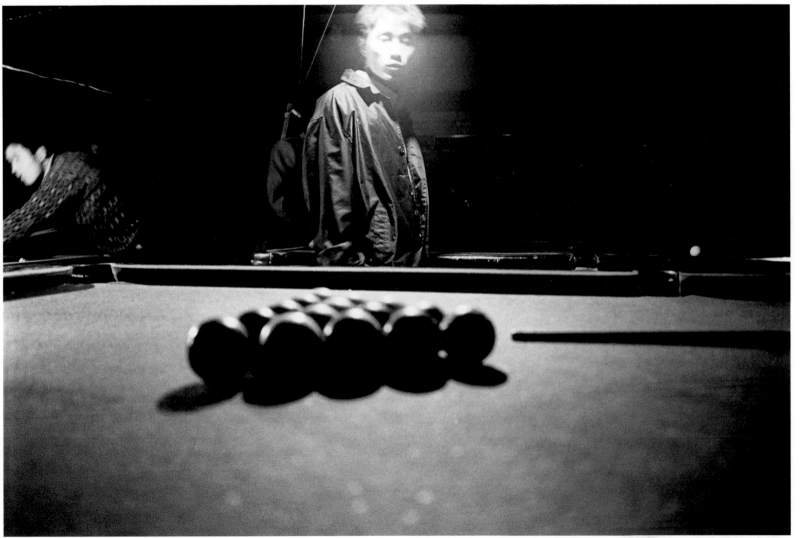

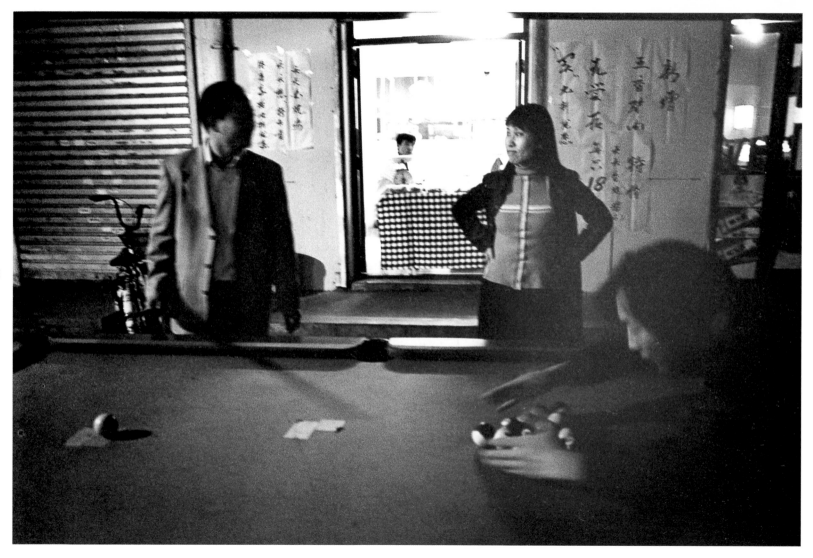

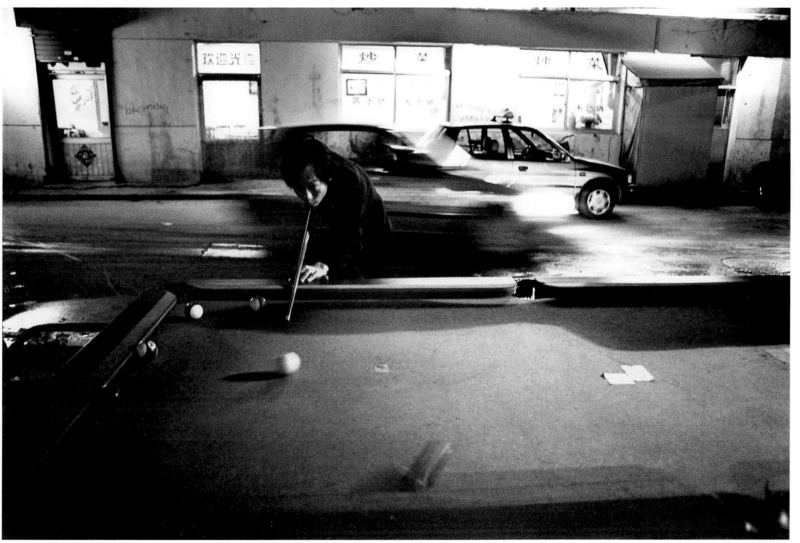

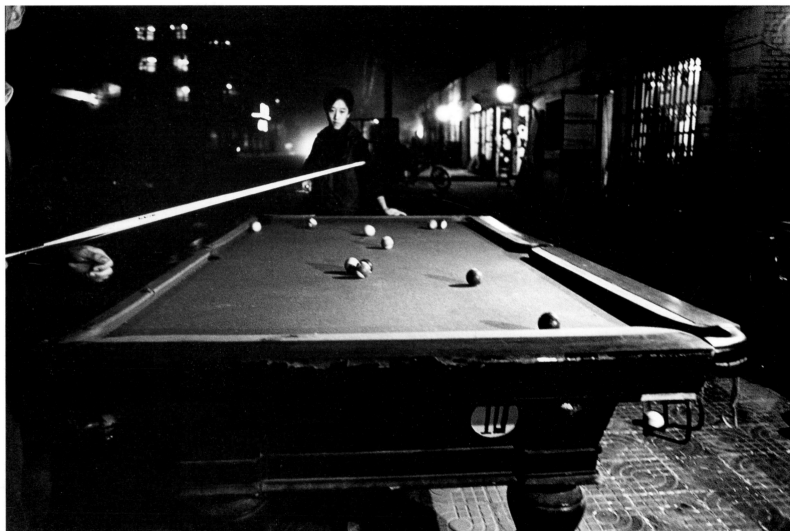

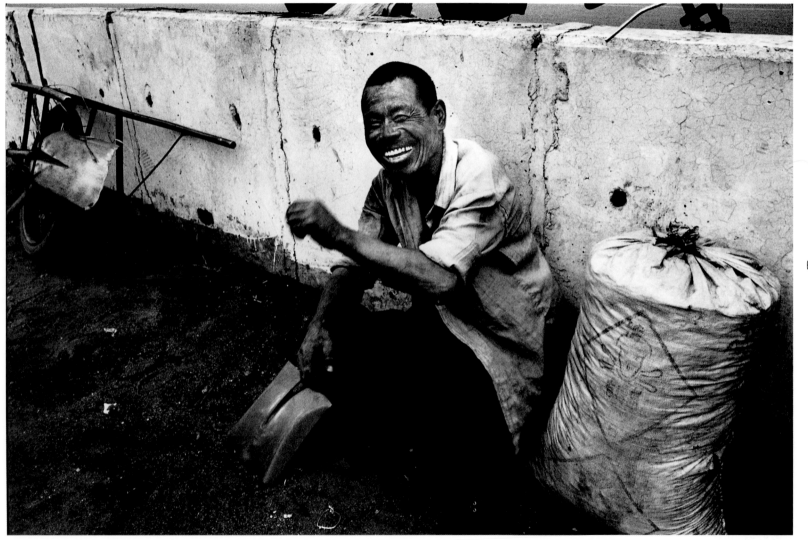

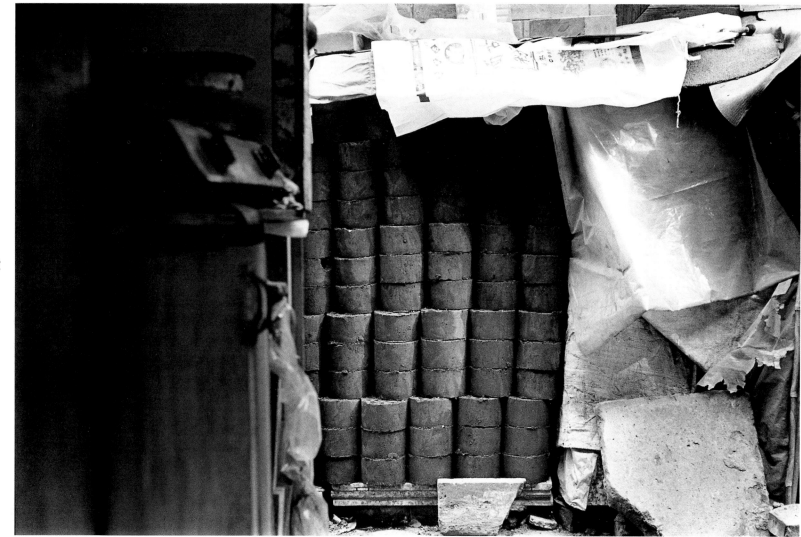

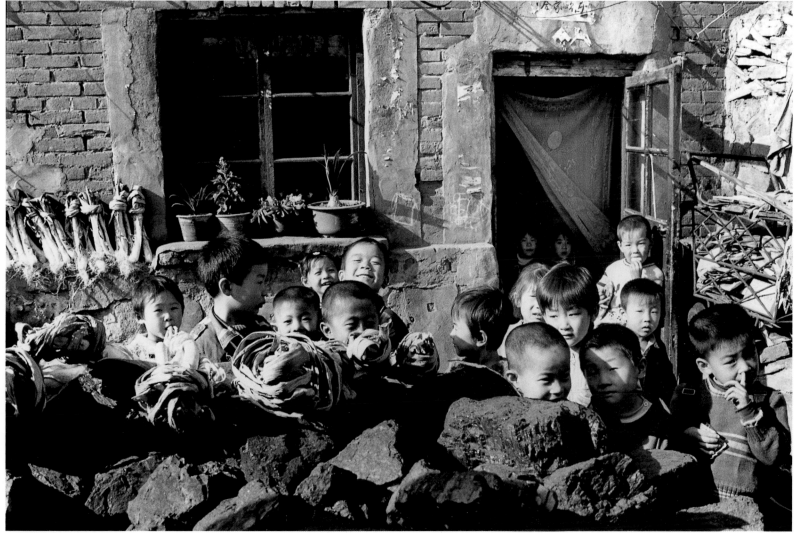

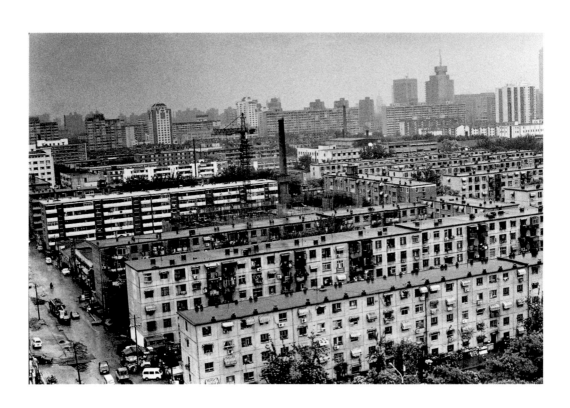

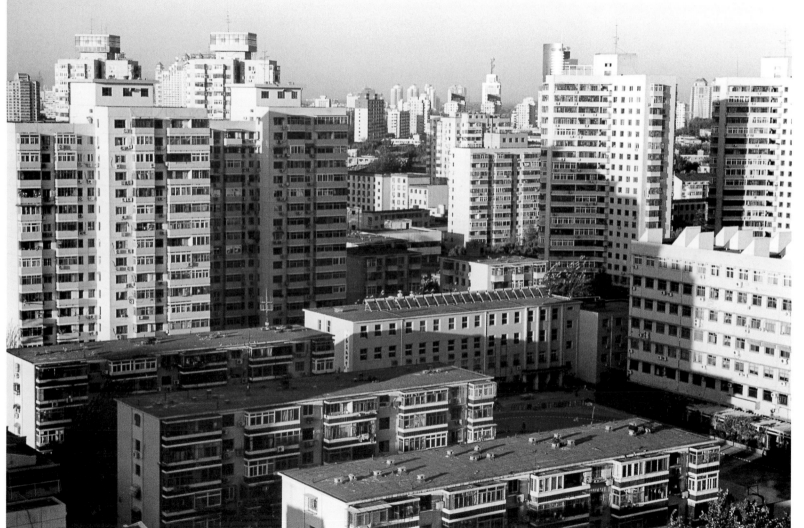

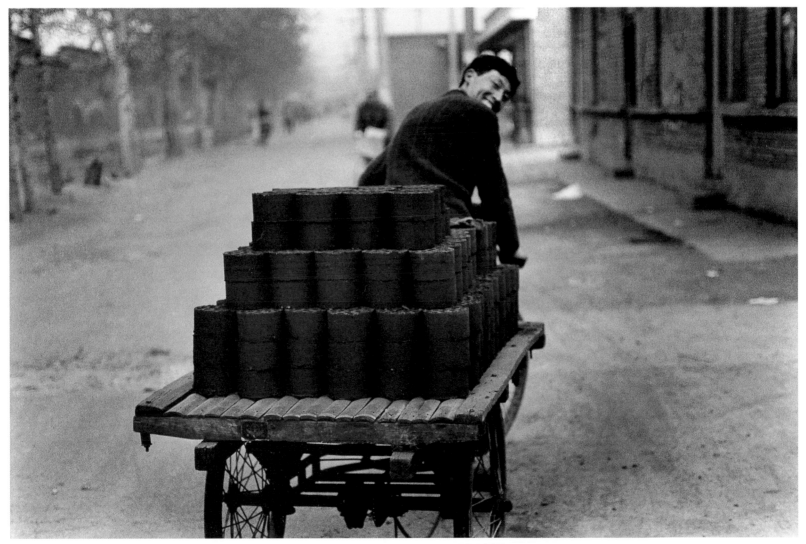

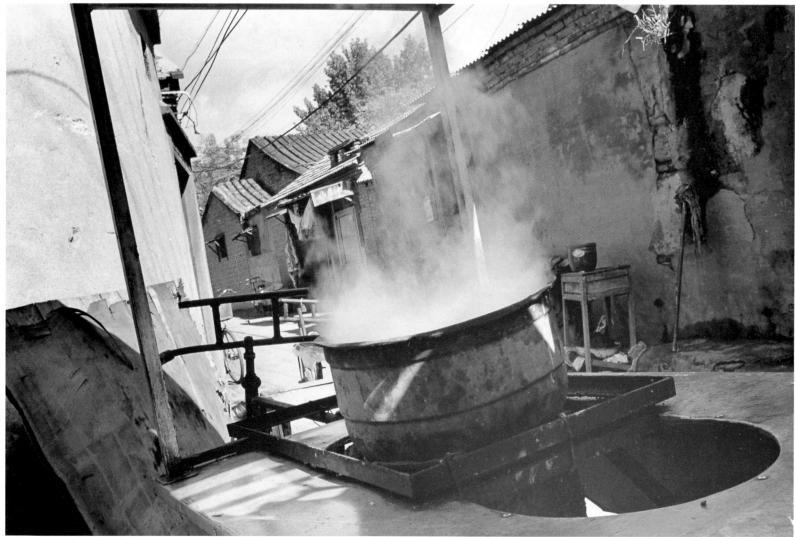

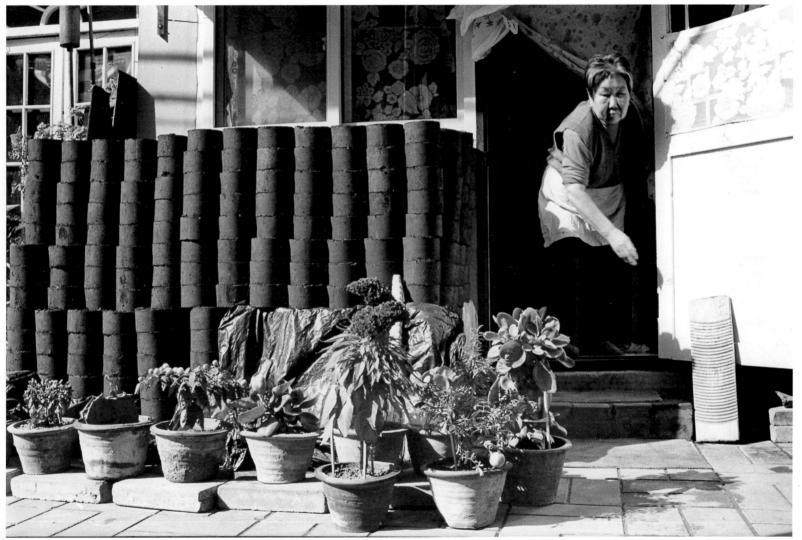

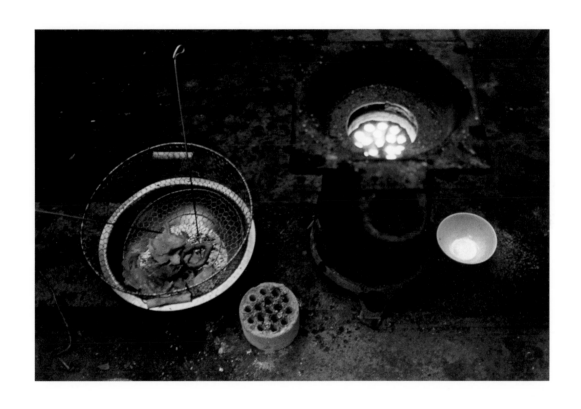

# La via del carbone

*Patrizia Bonanzinga*

Sono arrivata a Pechino il primo settembre del 1995. Ero con Lorenzo, mio figlio. Quell'arrivo resta un ricordo indelebile nella mia mente: il rapporto tra spazio, tempo e odori si riassumeva in un'esperienza del tutto illusoria. Solo il viso di Ferdinando, mio marito, che era venuto a prenderci, mi ha riportato alla realtà.

Durante quel primo autunno pechinese guidavamo una vecchia A112 in cui parte dei gas di scarico entravano all'interno dell'abitacolo rendendone l'aria simile a quella esterna. Di notte un'atmosfera densa e nebbiosa avvolgeva le strade alberate e malamente illuminate. Le luci dei fari investivano gli alberi che improvvisamente avanzavano con fare marziale, simile a quello delle squadre di militari, in fila per due, che spesso si incrociavano. Non un lampione illuminava la strada. Solo le luci al neon delle case, segmenti freddi e allineati, permettevano di intuire le facciate dei palazzi. Pochissime macchine circolavano per i viali del quartiere "elegante" delle ambasciate.

Mi sentivo costantemente immersa in uno strano odore. Quello stesso odore che ci accolse all'aeroporto: un odore acre misto di ossido di carbonio e disinfettanti primitivi. Ho cominciato a seguire quell'odore e, in modo del tutto naturale, mi sono trovata sulla mia "via del carbone": una strada che ho percorso e ripercorso a più riprese durante tutto il mio periodo pechinese. E anche più tardi.

I primi tempi guardavo e scoprivo. Scoprivo che il carbone in città era onnipresente: lungo le strade principali, ammassato negli angoli dei templi, accatastato all'interno dei *si he yuan* – le case tradizionali dai cortili quadrati –, lungo gli *hutong* – gli stretti vicoli della vecchia città –, nelle scale dei nuovi condomìni, dentro i ristoranti, per la strada accanto alle bettole.

Poi ho cominciato a fotografare. Era come essere entrata in un tunnel nero. Una galleria priva di uscita. Un tunnel simile a quello che percorrevo quando aprivo i miei libri di cinese o mi infilavo le cuffie per apprendere i toni e i suoni necessari a riconoscere le parole di quella lingua così lontana dalla nostra il cui apprendimento, non passando dalla lettura, risulta del tutto astratto. La scrittura poi è riconducibile a un disegno. Una grafia che si può sviluppare solo con regole ben precise: i caratteri si scrivono componendo dei tratti che vanno dall'alto verso il basso, da sinistra verso destra e così via. Ho così scoperto che l'ordine è un concetto fondamentale della cultura cinese: ogni cosa ha il suo posto, ogni persona ha il suo ruolo così come la struttura urbana della città tradizionale è regolata da una precisa geometria.

Nell'ordine geometrico urbano le mattonelle di carbone vengono impilate e ricoperte da plastiche o cartoni di vario tipo. Non riuscivo a privarmi dell'entrare dentro i vicoli, dentro le corti per cercare le mattonelle di carbone e parlare con la gente, sempre disponibile e curiosa verso una straniera che cercava di mettere goffamente in pratica i pochi rudimenti di cinese appresi. Gli abitanti di quei luoghi accoglievano con grande stupore il mio interesse per il loro carbone. In un certo senso anch'io ero stupita da me stessa: l'odore portava il mio sguardo verso il carbone, quell'odore muoveva un sentimento a me del tutto sconosciuto.

Quando poi ho cominciato a percorrere la strada che da Pechino porta verso Datong, nella

provincia dello Shanxi – grande centro di produzione del carbone –, mi sembrava di aver intrapreso un viaggio nello stupore. A volte gli sguardi che si posavano su di me mi facevano sentire come qualcuno che avanza a passi incerti su una superficie scivolosa. Cosa cercava una straniera, o forse uno straniero, da quelle parti? Dico "forse uno straniero" perché spesso venivo identificata come uomo. Mi sono sentita attratta dalla curiosità e dalla semplicità dei cinesi. In Cina può capitare di essere accucciata nell'ultimo dei buchi di un bagno pubblico per le donne, normalmente privi di divisori tra loro, e sentirti osservata dalla vicina, anch'essa nella medesima posizione per svolgere la medesima attività, che naturalmente incuriosita domanda: "È molto diverso da voi?".

Lungo la strada che collega Pechino con Datong si è sviluppata una particolare economia favorita dal transito degli innumerevoli camion pieni di carbone: mercati improvvisati, stazioni di servizio, ristoranti all'aperto, hotel, postriboli. I camionisti si fermano volentieri, si attardano davanti a un biliardo posto in mezzo alla strada o davanti a un barattolino di vetro, come quello che spesso mi veniva offerto, pieno di acqua calda con poche foglie di tè depositate sul fondo. La mia macchina fotografica era una specie di filtro che cercavo di usare in modo discreto per poter cogliere quell'atmosfera.

Poi sono entrata nelle miniere. Soprattutto in quelle piccole. Ho conosciuto i minatori, che possono essere anche molto giovani. Sono entrata nelle loro semplici case, formate da un'unica stanza dove spesso abita anche l'asino.

Lo Shanxi è una regione dal clima molto secco. Può fare anche molto freddo. I vapori densi provocati dal mio respiro a volte appannavano il mirino della mia macchina, la mia visione era spesso sfuocata, appannata come quella di un sogno. Quando c'è vento, poi, il cielo è limpidissimo, la luce è bellissima e il carbone vola come sabbia nel deserto ricoprendo con la sua polvere nera e grassa i corpi e le cose. Intorno a me facce nere, mani nere. Solo alla sera mi accorgevo che anche il mio viso e le mie mani erano nere come quelle che avevo incontrato durante tutta la giornata.

Dal mio primo arrivo, Pechino è enormemente cambiata. La modernizzazione avanza senza sosta. Oggi l'immagine della città è completamente diversa: il traffico è intenso, le biciclette in numero decisamente minore, si vedono anche delle biciclette elettriche. Gli autobus adesso sono verdi e gialli. Quelli vecchi, bianche a strisce rosse, sono spariti quasi del tutto dalle vie del centro; viaggiano soprattutto nei percorsi periferici. Quando sono ritornata, nel 2002, ho trovato un aeroporto moderno, asettico, qualsiasi, ma l'odore resta. Arrivando ho chiuso gli occhi e quello stesso odore rimandava la mia mente a quell'aeroporto elementare che era: si scendeva a piedi dall'aereo, si camminava sulla pista, si entrava lungo stretti corridoi pavimentati con graniglia e cemento, le pareti color verde ospedale. Arrivando in città ho provato un profondo senso di spaesamento: adesso imponenti arterie la tagliano da est a ovest, da nord a sud. Non riconoscevo i luoghi. Solo più tardi ho capito che a confondermi era piuttosto l'assurda idea che gli elementi architettonici urbani scomparsi, durante quel breve periodo di assenza, non si potessero più ricordare di me, del mio passaggio in quel luogo: non rappresentassero più la memoria di ciò che io stessa avevo dimenticato.

Sono ritornata nello Shanxi, sulle orme del "mio" carbone. Sono entrata nelle piccole miniere che si aggrappano alle pareti polverose dei canyon che penetrano in profondità perpendicolari alla strada maestra. Sugli spiazzi sovrastanti, attorno alle piccole miniere, i piccoli villaggi dei minatori. La cosa più stupefacente in quei luoghi, e di cui a tutt'oggi non

riesco ancora a capacitarmi, è stata per me sin dall'inizio il loro vuoto. Già il senso d'abbandono che regna nei villaggi, costruiti secondo il classico schema geometrico, è oltremisura deprimente, ma ancor più lo è l'aspetto delle facciate delle case, dietro le cui finestre tutto sembra immobile. Non riuscivo a immaginare chi potesse vivere in quelle desolate costruzioni, benché, d'altra parte, si trovassero nei cortili interni un gran numero di bidoni e oggetti di vario tipo, segni di presenza. Ma la cosa ancor più stupefacente, in qualsiasi desolato villaggio mi trovassi, è il riconoscere l'evidenza dei simboli della cultura cinese: l'arco memoriale, spesso in plastica o in ferro, che accoglie il visitatore; le scritte di buon auspicio attaccate ai lati delle porte; le pietre, scolpite anche in modo rudimentale ma sempre a coppia, raffiguranti i più strani animali; un busto di Mao Ze Dong, che rimanda al mito degli antenati, al centro di uno scaffale accanto alle ceneri di qualche parente; la ricorrenza di oggetti cifrati e numerati secondo regole fisse; la geometria dei villaggi che vista dall'alto rimanda alla calligrafia della scrittura cinese.

La notte, che tenessi gli occhi aperti oppure chiusi, continuavo a vedere le immagini di quei luoghi: i mattoni polverosi delle case, le vetrine dei punti di vendita, le prospettive dei vicoli nel mio mirino, i portoni chiusi, la polvere di carbone tra le pietre del selciato, i mucchi di carbone davanti alle porte, il silenzio rotto soltanto dal sibilo del vento.

Per quanto io possa risalire indietro col mio pensiero, mi sono spesso sentita come priva di un posto nella realtà, come se non esistessi affatto, e mai questa sensazione è stata così forte quanto durante i miei viaggi in quei territori, lungo la mia "via del carbone". E per me non esiste creazione possibile se non in questa indeterminatezza.

# The road to coal

*Patrizia Bonanzinga*

I arrived in Beijing on September 1st, 1995. I was with Lorenzo, my son. That arrival remains an indelible memory in my mind: the relationship between space, time and smells took on the air of a totally illusory experience. Only the face of Ferdinando, my husband, who had come to meet us, brought me back to reality.

During that first autumn in Beijing, we drove an old Autobianchi A112 in which part of the exhaust would enter the car interior, making the air inside similar to that outside. At night, a dense, foggy atmosphere would envelope the tree-lined, poorly-illuminated roads. The car lights would reveal the trees, which would suddenly advance with a military step, similar to that of the platoons of soldiers we would often come across, marching two by two. No street-lamps used to light the road. Only the neon lights of the houses, cold, regularly-aligned patches of light, would make it possible to make out the fronts of the housing blocks. There were very few cars on the roads of the "elegant" quarter of the embassies.

I felt myself to be constantly immersed in a strange smell. That same smell that met us at the airport: a bitter smell made of a blend of carbon dioxide and primitive disinfectants. I began to follow that smell and, in quite naturally, soon found myself on my "coal road": a road that I travelled repeatedly during my stay in Beijing. And after.

The first times, I watched and discovered. I discovered that coal was omnipresent in town: along the main roads, heaped up in the corners of temples, in piles within the *si he yuan* – the traditional houses with square courtyards – along the *hutong* – the narrow lanes in the old city – on the stairs of new apartment blocks, in restaurants, by the road alongside taverns.

Then I began to take photographs. It was like entering a black tunnel. A tunnel with no exit. A tunnel similar to the one facing me when I used to open my books of Chinese and would slip on the headphones to learn the tones and sounds necessary for understanding this language, so far from our own. Learning it in a manner dissociated from reading made it wholly abstract. The writing itself is similar to drawing, and is a form that can be developed only in accordance with strict rules: the characters are written in lines going from the top down, from left to right and so on. Thus it was that I learned that order is a fundamental concept in Chinese culture: everything has its place, everyone has his role to play, and the urban structure of the traditional city is regulated by a precise geometry.

Within the geometric order of the city, the coal briquettes are heaped up and covered in plastic sheeting or cardboard of various types. I couldn't resist entering the little lanes and courtyards to look for the little piles of coal and talk to the people I found; they were always receptive and curious to see a foreigner trying clumsily to practise the few rudiments of Chinese learned. The people who lived in these places were astonished at my interest in their coal. In a certain sense, I was surprised at myself as well: the smell would attract my attention to the coal; the smell would stir a feeling in me that was totally unknown.

Then, when I began to follow the road leading from Beijing to Datong, in Shanxi province – a major centre of coal production – I felt I was undertaking a voyage into amazement. The eyes that were turned to me sometimes made me feel like someone taking faltering steps on a slippery surface. What was a foreign woman, or perhaps a man, looking for around

there? I say "perhaps a man" because I was often mistaken for a man. I felt attracted by the curiosity and simplicity of the Chinese. In China, it can happen that you are crouching in the last of the line of tubs in a public bathhouse for women, which normally have no screens between them, and feel yourself observed by your neighbour, herself seated in the same way for the same reason, who, naturally curious, asks: "Is it very different in your country?"

Along the road linking Beijing to Datong, a special economy has grown up thanks to the transit of numberless lorries loaded with coal: improvised markets, service stations, open-air restaurants, hotels, brothels. The lorry-drivers are happy to stop, lingering in front of a billiard table in the middle of the road, or with a little glass tumbler – of the sort often offered me – full of hot water and with a few tea-leaves on the bottom. My camera was a sort of filter that I sought to use discreetly to try and capture that atmosphere.

Then I went to visit the mines. Especially the small ones. I met the miners, who were often very young. I entered their simple homes, comprising a single room in which the donkey frequently also lived.

Shanxi is a region with an extremely dry climate. It can also be very cold. The dense clouds of vapour I produced on breathing out sometimes steamed up my camera viewfinder, and my vision became unfocused, as though in a dream. When it is windy, the sky is very clear, the light wonderful and the coal flies like sand in the desert, covering people and objects with its black, greasy dust. Around me would be black faces, black hands. Only in the evening would I realise that my face and my hands were as black as those I had come across during the day.

Since I first went, Beijing has changed enormously. Modernisation advances ceaselessly. Today, the city looks completely different: the traffic is intense, the bicycles clearly fewer in number, and there are even some electric bicycles. The buses now are green and yellow. The old ones, white with a red stripe, have vanished almost completely from the central streets; they operate above all in the outskirts. When I went back in 2002, I found a modern, almost antiseptic airport, but the smell was still there. When I arrived, I closed my eyes and that same smell brought back to my mind the basic airport that used to be there: one would walk down the steps from the plane on to the apron and enter long, narrow corridors with a grit-and-cement floor and hospital-green walls. Arriving in town, I found myself completely disoriented: major trunk roads cut the city from east to west, north to south. I no longer recognised the places. Only later did I realise that what confused me was the rather absurd idea that the architectural features that had vanished during the short period I was away would no longer be able to remember my passage in that place. That they would no longer represent the memory of what I had myself forgotten.

I went back to Shanxi, following the tracks of "my" coal. I went to the little mines that cling to the sides of the dusty cliffs of the canyons stretching away at right angles to the main road. In the spaces above them, around the little mines, were the miners' small villages. The most astonishing thing for me in these places, something I have been unable to come to grips with since the outset, is their emptiness. The sense of neglect that reigns in these villages, built in line with the classic geometric plans, is exceedingly depressing, but even more so is the look of the fronts of the houses, behind the windows of which nothing seems to stir. I could not imagine who might live in these desolate buildings, even though the inner courtyards contained a large number of containers and objects of various sorts and so betrayed a presence. But the even more astonishing thing was to recognise the evidence of

the symbols of Chinese culture in whichever desolate village I might visit: the memorial arch, often of plastic or metal, welcoming the visitor; the good-luck texts stuck to the sides of the doors; the stones, often sculpted in the most rudimentary manner but always in pairs, depicting the strangest of animals; a bust of Mao Zedong, recalling the myth of the ancestors at the centre of a shelf alongside the ashes of some relative; the recurrence of objects coded and numbered in accordance with fixed rules; the layout of the villages that from above recalls the calligraphy of Chinese writing.

At night, whether I kept my eyes open or closed, I continued to see the images of those places: the dusty bricks of the houses, the store windows, the views down the lanes seen through my viewfinder, the closed doors, the coal-dust between the paving stones, the heaps of coal in front of the doors, the silence broken only by the whistling of the wind.

Although I can go back with my thoughts, I have often felt as though deprived of a place in reality, as though I didn't exist at all, and never has this sensation been so strong as during my journeys in those places, along the "coal road". And as far as I concerned, no creation is possible except in this indeterminacy.

# La route du charbon

*Patrizia Bonanzinga*

Je suis arrivée à Pékin le 1er septembre 1995, avec mon fils Lorenzo. Cette arrivée est un souvenir indélébile dans ma mémoire : le rapport entre espace et temps se conjuguait avec les odeurs en une expérience qui relevait complètement de l'illusion. Seul le visage de Ferdinando, mon mari, venu nous chercher, me ramenait à la réalité.

Au début de notre séjour pékinois, nous conduisions une vieille Autobianchi A112 dont les gaz d'échappement refoulaient en partie dans l'habitacle, l'air finalement n'y était guère différent de celui qu'on respirait dehors. La nuit, une atmosphère dense et brumeuse recouvrait les rues à peine éclairées, bordées d'arbres. Le faisceau des phares leur donnait aux arbres une allure martiale, on s'attendait à ce qu'ils se déplacent deux par deux, comme les militaires qu'on croisait souvent. Il n'y avait pas de réverbère, seuls les néons des appartements, segments froids alignés, nous permettaient de deviner la façade des immeubles. Très peu de voitures circulaient dans les avenues du quartier "chic" des ambassades.

Je me sentais constamment imprégnée d'une odeur étrange. Cette odeur âcre qui nous avait accueillis à l'aéroport, un mélange d'oxyde de carbone et de désinfectant ordinaire, qui a commencé à m'obséder. Elle m'a mise, tout naturellement, sur la "route du charbon", une route que j'ai parcourue à plusieurs reprises durant ma période pékinoise. Et par la suite aussi.

Les premiers temps, je regardais et je découvrais. Les briques de charbon était omniprésent dans la ville : le long des artères principales, des rues, des *hutongs* (les étroits passages de la vieille ville), entassées dans les recoins des temples, empilées à l'intérieur des *si he yuan* (les maisons traditionnelles à cour carrée), dans les escaliers des immeubles, dans les restaurants, près des débits de boissons et gargotes installés sur les trottoirs.

J'ai commencé à photographier. C'était comme si j'étais rentrée dans un tunnel noir. Un boyau sans issue. Un tunnel comme celui que je traversais lorsque, ayant ouvert mes manuels de chinois et installé un casque sur mes oreilles, je me concentrais sur les tons et les sons nécessaires pour appréhender cette langue si éloignée de la nôtre et dont l'apprentissage, s'il ne passe par la lecture, se révèle totalement abstrait. L'écriture renvoie au dessin, suit des règles précises : les caractères sont composés de traits allant de haut en bas, puis de gauche à droite. L'ordre est un concept fondamental de la culture chinoise : chaque chose a sa place, chaque personne a son rôle, à l'instar de la structure de la ville traditionnelle qui répond à une règle géométrique précise.

Dans l'ordre urbain, les briquettes de charbon sont empilées et recouvertes de plastique ou de cartons en tout genre. Je ne résistais pas à entrer dans les impasses, les cours, pour traquer ces briquettes et parler avec les gens, toujours disponibles et curieux envers une étrangère qui, maladroitement, essayait de mettre en pratique les rudiments de chinois qu'elle avait acquis. Les habitants étaient étonnés par l'intérêt que je portais à leur charbon. D'une certaine manière, moi aussi : l'odeur guidait mon regard vers le charbon, tout en éveillant en moi un sentiment complètement inconnu.

En parcourant ensuite la route qui relie Pékin à Datong (dans la province du Shanxi, un grand centre de production du charbon), j'eus l'impression de traverser un monde de stupeur. Parfois, les regards qui se posaient sur moi me faisaient me sentir comme

quelqu'un qui avance à pas incertains sur une surface glissante. Que venait chercher une étrangère, ou un étranger – souvent on me prenait pour un homme –, par ici ? La curiosité et la simplicité des Chinois m'attiraient. En Chine, il peut arriver d'être recroquevillé dans le dernier des trous de WC publics pour femmes, habituellement sans séparation, et de se sentir observée par une voisine, qui soudain vous demande : "C'est très différent chez vous ?".

Entre Pékin et Datong, toute une économie spécifique se développe au gré du transit des innombrables camions remplis de charbon : marchés improvisés, stations service, restaurants en plein air, hôtels et des lupanars. Les routiers s'arrêtent, s'attardent devant un billard dressé au beau milieu de la route ou autour d'un pot en verre, identique à celui qu'on me tendait souvent, rempli d'eau chaude et dans lequel flottaient deux ou trois feuilles de thé. Mon appareil photo était devenu le filtre que j'utilisais discrètement pour saisir cette atmosphère.

Puis je suis rentrée dans les mines. Surtout les petites mines. J'ai rencontré les mineurs, dont certains étaient très jeunes. Leur maison, modeste, était constituée d'une unique pièce, où logeait aussi le plus souvent un âne.

Le Shanxi est une région au climat très aride. Il peut aussi y faire très froid, ma respiration embuait parfois le viseur de mon appareil photo et ma vision devenait floue comme dans un rêve. Quand le vent se lève, le ciel devient limpide et la lumière superbe, le charbon soulevé comme le sable du désert recouvre d'une poussière noire et grasse les corps et les choses. Autour de moi, des visages noirs, des mains noires. C'est le soir seulement que je me rendais compte que mon visage et mes mains étaient noirs comme ceux que j'avais vus toute la journée.

Pékin a beaucoup changé depuis mon premier voyage en Chine. La modernisation ne cesse de remodeler la ville: la circulation est intense, les vélos sont moins nombreux et certains sont même dotés d'un moteur électrique. Les autobus sont maintenant verts et jaunes, reléguant les vieux autobus blancs à bandes rouges au rebut ou en périphérie. Quand je suis revenue en 2002, le nouvel aéroport, modernisé, aseptisé, banal, avait néanmoins conservé l'odeur. En fermant les yeux, cette odeur me transportait en esprit dans le bâtiment sommaire qu'il avait été : on descendait à pied de l'avion, on marchait sur la piste, on empruntait d'étroits couloirs, dont le sol était recouvert de ciment et de gravillons, entre des murs peints en vert tilleul. A mon arrivée en ville, j'ai éprouvé un profond sentiment de dépaysement : d'imposantes artères la traversaient maintenant d'est en ouest et de nord au sud. Je ne reconnaissais pas les lieux. Ce n'est que plus tard que j'ai compris que me troublait l'idée que les éléments architecturaux disparus pendant ma brève absence ne se souvenaient plus de moi ni de mon passage dans ces lieux : ils ne représentaient plus la mémoire de ce que moi-même j'avais oublié.

Je suis retournée dans le Shanxi, sur les traces de "mon" charbon, dans les petites mines accrochées aux parois poussiéreuses des canyons et qui pénètrent en profondeur, perpendiculairement à la route. Les villages des mineurs sont agglutinés autour de ces mines, sur les esplanades situées au dessus. La caractéristique de cet endroit, que je n'arrive toujours pas à comprendre, c'est le vide qui y règne. Le sentiment d'abandon dans ces villages, construits selon le dispositif traditionnel, est déprimant, mais ce qui l'est plus encore, c'est l'aspect des façades et des fenêtres derrière lesquelles tout semble figé. Impossible d'imaginer qu'on puisse vivre dans ces constructions désolées, en dépit de tous les bidons et divers objets qui jonchent le sol des cours intérieures et sont un signe manifeste de vie. Mais, plus surprenante encore, c'était la présence dans le moindre de ces

villages des symboles de la culture chinoise : le portique, souvent en plastique ou en fer, qui accueille le visiteur ; les banderoles de bon augure placées de part et d'autre de la porte ; les pierres sculptées, plus ou moins finement, allant toujours de paire, qui représentent les animaux les plus étranges qui soient ; un buste de Mao Zedong, qui ramène au mythe des ancêtres, placé au centre d'une étagère à côté des cendres de parents ; la récurrence d'objets identifiés et numérotés selon des règles précises ; la géométrie des villages qui rappelle la calligraphie chinoise.

La nuit, que mes yeux soient ouverts ou fermés, les images de ces lieux me poursuivaient : les briques poussiéreuses des habitations, les vitrines des commerces, la perspective des ruelles dans mon viseur, les portes fermées, la poussière de charbon entre les pavés, les tas de charbon devant les portes, le silence interrompu par le sifflement du vent.

Pour autant que je puisse remonter le temps par la pensée, je me suis souvent sentie comme privée d'un ancrage dans la réalité, comme si je n'existais pas, et cette sensation n'a jamais été aussi forte que pendant mes voyages en ces terres, le long de ma "route du charbon". Et pour moi il n'y a de création possible que dans ce trou noir, cet entre-deux.
[traduit de l'italien par Patrizia Bonanzinga]

# Fiutare l'immagine

*Roberto Salbitani*

Da dove inizia a fotografare uno appena arrivato in Cina?

Stiamo parlando della Cina, di un'entità immensa, di un universo. Quando ci chiedono a noi fotografi da dove è partito quello o quell'altro dei nostri racconti visivi, normalmente ci grattiamo la testa. Chissà se è stata un'immagine che ci ha colpiti da bambini, una lontana traccia, un ricordo, il desiderio di gettare luce su qualcosa che preme da dentro ma che è molto confuso. Forse i punti di partenza sono stati tanti nel tempo e diversi e hanno finito per sovrapporsi, ed è meglio dunque lasciar perdere. Nel caso di Patrizia Bonanzinga un organo, il naso, con quell'autorevolezza che gli compete e che è spesso tanto più lucida quanto più gli altri sensi si dibattono nell'opacità, si è messo a modo suo a fare click.

*Mi sentivo costantemente immersa in uno strano odore. Quello stesso odore che ci accolse all'aeroporto: un odore acre misto di ossido di carbonio e disinfettanti primitivi. Ho cominciato a seguire quell'odore e, in modo del tutto naturale, mi sono trovata sulla mia "via del carbone": una strada che ho percorso e ripercorso a più riprese durante tutto il mio periodo pechinese. E anche più tardi.*

Da questo fiutare ha inizio e sviluppo il racconto visivo dove quest'odore che attira e indica la direzione, per un misterioso gioco di corrispondenze, si consegna al nero del carbone. Che è il combustibile che sappiamo ma che ha una ragione in più per esserlo per un fotografo in bianconero.

*Lo Shanxi è una regione dal clima molto secco: può fare anche molto freddo. I vapori densi provocati dal mio respiro a volte appannavano il mirino della mia macchina, la mia visione era spesso sfuocata, appannata come quella di un sogno. Quando c'è vento, poi, il cielo è limpidissimo, la luce è bellissima e il carbone vola come sabbia nel deserto ricoprendo con la sua polvere nera e grassa i corpi e le cose. Intorno a me facce nere, mani nere. Solo alla sera mi accorgevo che anche il mio viso e le mie mani erano nere come quelle che avevo incontrato durante tutta la giornata.*

Questa è una prima sensazione ma forse già indica una carta d'identità davvero molto diversa rispetto a quel predominante elemento ordinatore, razionale, sotteso a molto fotogiornalismo maschile che proprio in Cina ha inseguito una sua necessità e un suo sogno. Ne parleremo tra poco. Qui invece quello che sotto i nostri occhi sta prendendo corpo ora è un album di viaggio, un diario privato/pubblico che sfortunatamente è solo visivo dato che quasi aspirerebbe a coinvolgere anche gli altri sensi. Non ci sono tramiti: vuole arrivare subito a noi, accorciando le distanze e facendo fiutare anche a noi qualcosa di quel peculiare sentore di Cina, di un pezzettino di Cina che però già basta per un cammino a ritroso nel corpo. La strada del carbone percorsa, vissuta e fotografata entra in quel dominio che è dei rapporti di attrazione, dei rapporti "fisici". Odori, spazi, silenzi, attese. Il bianconero qui va a nozze, nel senso che il carbone sembra diventare il traino ideale per lo spogliamento del colore. Che sappiamo può trarre in inganno e soprattutto, visto che parliamo di Cina, non è il caso proprio di fornire al cervello le polverine d'oro che portano agli esotismi e alle policrome narcosi. Quanto più il colore può essere estroverso e superficiale talvolta al limite del bla bla bla, tanto più il bianconero misura il dissidio interno alle cose fino al punto da evocare contrapposizioni, incongruenze, muri che si frappongono tra il materiale e l'ideale. È sempre in un certo senso "nudo" e credo che facilmente lo associamo nel nostro immaginario a ciò che è essenziale. Il suo movimento

rispetto alle apparenze "ingannatrici" sembra perfino mimare quello dello scavo, del minatore...

La strada del carbone della Bonanzinga è dunque solo un pezzettino di Cina, di quella terra immensa e "altra" di cui da sempre si è detto, scritto, rappresentato e soprattutto favoleggiato. Di Cina sono sempre stati pieni gli scaffali delle biblioteche e i recessi più oscuri della nostra psiche. Ma Patrizia non si è posta programmaticamente il compito di scalzare dal piedistallo la Cina dei miti, delle seduzioni e fantasie culturali. Ha semplicemente scelto, anzi, è stata scelta da una strada e l'ha percorsa come facendosi trasportare dal vento delle immagini reali, quelle cioè offerte dagli incidenti di percorso, dagli incontri con i frequentatori quotidiani di quella strada. Che questa "striscia" di Cina pur essendo solo un microcosmo non sia per nulla un incidente personale e che vada oltre la semplice intuizione è implicito mi pare nella stessa ambigua fisicità oltre che nel significato metaforico che assume il carbone:

*La notte, che tenessi gli occhi aperti oppure chiusi, continuavo a vedere le immagini di quei luoghi: i mattoni polverosi delle case, le vetrine dei punti di vendita, le prospettive dei vicoli nel mio mirino, i portoni chiusi, la polvere di carbone tra le pietre del selciato, i mucchi di carbone davanti alle porte, il silenzio rotto soltanto dal sibilo del vento. Per quanto io possa risalire indietro col mio pensiero, mi sono spesso sentita come priva di un posto nella realtà, come se non esistessi affatto, e mai questa sensazione è stata così forte quanto durante i miei viaggi in quei territori, lungo la mia "via del carbone". E per me non esiste creazione possibile se non in questa indeterminatezza.*

A un restringimento di orizzonti geografici, mitologici e culturali si contrappone un massimo di ricerca del contatto possibile, un accorciamento della distanza fisica che separa la fotografa dalla gente. E immaginiamo tutta la difficoltà di questo avvicinamento a una popolazione dove ognuno si ritaglia uno spazio individuale che, per rispetto e reciproca salvaguardia – simbolica ma nel senso dell'estrema concretezza ed efficacia del simbolo –, non si deve violare. C'è come un cubo d'aria interdetto attorno a ogni cinese, e ciò a saperlo ben interpretare la dice lunga sulle sofferenze causate al singolo dalle traversie, dalle condizioni storiche, politiche e naturali, che hanno schiacciato nel corso di secoli e secoli questa popolazione. Soprattutto i contadini e gli abitanti dei villaggi. Dove la salvezza individuale ha sempre dovuto lottare contro fenomeni dalle proporzioni smisurate.

In "Cuore Gioioso, tassista/carrettiere di Pechino", Lao Che ci racconta che un vecchio carrettiere, sputando per terra e girandosi verso Cuore Gioioso, gli disse "Ah! Hai creduto di potertela sbrogliare da solo? E chi non l'ha creduto? Ma dove sono quelli che ci sono riusciti? Te lo dico io. Su cosa può contare un uomo da solo? Hai mai guardato le cavallette? Da sole, possono anche saltare come matte ma ci sarà sempre un ragazzino pronto a prenderle e a legar loro un filo a una zampetta per impedirne il volo. Ma eccole riunirsi in massa, schierate come un esercito. Houp! Basta una folata ed ecco che il campo è raso al suolo. E chi le ferma?".

Dalla leggenda sulle masse scatenate e incontrollabili, sui cinesi-cavallette, si può solo sfoltire se si vuole cominciare a vedere come stanno davvero le cose. C'è solo un movimento possibile ed è un ritorno: dall'entità astratta e generalizzata al particolare concreto, dal tempo del mito e dall'oscurità della psiche al presente che resta materialmente rappreso sulla pellicola fotografica. Solo l'accorciamento della "distanza di sicurezza", l'avvicinamento alla zona di intimità proibita, poteva consentire alla Bonanzinga di realizzare quei ritratti di individui non "culturali", di corpi, che andava inseguendo. Presi da lontano e da dietro, i minatori sono generici minatori, uguali a tutti i minatori, e così gli abitanti dei villaggi che si affacciano sulla strada e la gente di passaggio. Ma è sul volto

del giovane minatore che è a tu per tu con lei, e quindi con noi che oggi lo incontriamo a pagina 14 dell'album, oppure su quello del ragazzo a pagina 45, che Patrizia evidenzia perfettamente il suo intendimento. Che è appunto soprattutto quello di "segnare" il suo sentimento su quei volti ispessiti di umano: le vere mappe geografiche della Cina. Uomini e donne cinesi incontrati oggi che richiamano quelli che lei si porta dentro e che chissà in quali lande abitano. Istanti veri e insieme sublimati dallo strumento frapposto, che però produce anche lui le sue piccole violenze (non assegna un mirino a sua volta a chi viene inquadrato!).

È semplicemente la sua strada del carbone.

Il libro si presenta anche fisicamente in un perfetto formato condensato e personalizzato che rafforza giustamente la sua dimensione d'album. In copertina l'immagine di due guanti consunti – appoggiati sopra le mattonelle di carbone tonde e tipicamente traforate – rimanda immediatamente a quella dimensione di fisicità, di umanità che vive e fatica a stretto contatto con il necessario. Le "mani" deformate sembrano trasmettersi calore nel loro conferire forma artigianale all'amorfa massa di carbone. Praticità e dimensione estetica qui significativamente convivono nella tattilità della dimensione rotonda, che è poi quella che meglio conforma lo stile di vita cinese.

Ma dopo questa partenza di un simbolismo così marcato, l'album si apre libero nello spazio e nel tempo quotidiano eppur universale del carbone. Che è poi il viaggio di una fotografa che non fa che aggiungere, sosta dopo sosta, sguardo dopo sguardo, le sue mattonelle di pieno e di vuoto. La strada si snoda tra montagnole dai terrazzamenti spianati, percorse da vecchi camion tutti uguali, da carrettini tirati dai muli. Un paesaggio medievale uniformato dalla grande nuvolaglia nera che si insinua dappertutto, da cui il sorprendere e lo spiare della fotografa distacca istanti di luce e di attenzione.

Sono proprio queste istantanee che pervengono ad arrestare, come invertendone la marcia, il continuo flusso e riflusso di corpi e di utensili usurati in perfetta simbiosi – nella ripetizione alla base di uno schema sociale e di una condizione di vita che parrebbe sempre più o meno uguale a se stessa. Non se ne ricava certo l'immagine pubblicitaria di una Cina "futurista" di quelle che generalmente piacciono ai suoi governanti; ma qui dentro c'è la migliore "triade" cinese: rispetto, gentilezza, benevolenza. Se un furto all'occidentale è stato commesso, visti i modi gentili, e rispettosi della tradizione, della fotografa/ladra, il derubato se ne congratulerebbe…

Rispetto ai libri di viaggio di grande respiro e fondati su molte articolazioni tematiche, spesso approfondite nel corso di più soggiorni avvenuti in periodi successivi e con diverse sistemazioni, non ci nascondiamo che vorremmo che altri rivoli venissero a ingrossare il fiume di queste immagini. Ma quest'album si attiene onestamente alle sue premesse, che sono innanzitutto espressive: più testimonianza sensibile, in delicato equilibrio tra il vissuto e l'osservato, che rappresentazione fotogiornalistica ben confezionata per piacere al lettore. In questo senso la sua autenticità rappresentativa si distacca nel panorama contemporaneo delle pubblicazioni patinate. Soprattutto, come accennavamo un attimo fa, ha il grande merito di non sovrapporsi ai passati favoleggiamenti sulla Cina e i cinesi e a tutto l'arcipelago delle esotiche cineserie.

A questo punto non posso qui esimermi da un rimando alla Cina dei fotogiornalisti, in particolare riguardo ad alcune considerazioni a cui alludevamo. Mi riferisco alla difficoltà di andar oltre la cortina imposta dal sospetto politico o dalla prudenza nel contatto con lo straniero o dalla semplice riservatezza personale. Nel suo *Les trois bannières de la Chine* del 1966 Marc Riboud scrive:

*Il modo migliore, e forse l'unico, per scoprire la Cina è di osservarla. In tutti i paesi del mondo lo straniero è aiutato, nella comprensione del paese stesso, dai contatti umani, dal*

dialogo con la gente: ma in Cina tutto ciò è impossibile. Lo straniero, anche se conosce la lingua cinese, non può mai avere un contatto diretto, immediato e spontaneo con la popolazione… in realtà, solo grazie all'accumulo di un'enorme quantità di informazioni e confrontando le diverse impressioni visive – al confronto con la realtà di altri paesi – si può ottenere un'immagine della Cina attuale.

Nonostante le difficoltà culturali Riboud in questo libro tenta di costruire – con grande efficacia e attenendosi il più possibile a un principio di "verità" oggettiva – il grande mosaico della condizione politica e sociale della Cina all'epoca del "grande balzo in avanti" e della Rivoluzione culturale. Lo scritto e le didascalie che accompagnano le fotografie a colori mescolate con quelle in bianconero sono indispensabili qui nel situare e nel far comprendere il contesto delle immagini: ne esce un ritratto sincero e credibile nella misura in cui sopravvive alle tentazioni dell'esaltazione ideologica o, peggio, della cosciente mistificazione. La simpatia e il fascino che il paese esercita su di lui non sono mai raffreddati dall'impostazione documentaria e conoscitiva del suo abile reportage.
Questo lavoro non poteva non avere riferimenti diretti al maestro Cartier-Bresson e alla sua grande epopea visiva della Cina al tempo della caduta del Kuomintang e dell'arrivo degli eserciti di Mao Ze Dong (1948-1949): parliamo di quel grande libro fotografico – intelligente, audace, investigativo al limite dell'incolumità personale – e cioè *D'une Chine à l'autre*, pubblicato a Parigi nel 1954 da Delpire. Qui forse per la prima volta in un modo così eclatante la fotografia sopravanza la parola scritta nel resoconto storico: con Cartier-Bresson, naturalmente al momento giusto e nel posto giusto, la storia viene pedinata (come direbbe Zavattini) "à la sauvette".
Jean-Paul Sartre scrive nella prefazione:

Da bambino fui vittima del pittoresco: avevano fatto di tutto per far nascere in me un sacro terrore dei cinesi. Mi parlavano di uova marce, di cui essi erano golosi, di uomini segati fra due assi, di musica esile e discordante. Nel mondo che mi circondava c'erano cose e bestie che chiamavano cinesi: erano minute e terribili, sfuggivano tra le dita, attaccavano alle spalle, scoppiavano all'improvviso con assurdo frastuono – ombre guizzanti al pari di pesci lungo il vetro di un acquario, lanterne soffocate, raffinatezze futili e incredibili, supplizi ingegnosi, cappelli sonori. C'era anche l'anima cinese che mi si definiva semplicemente impenetrabile.

E riferendosi direttamente alle fotografie di Cartier-Bresson:

Fate posare i vostri modelli e darete loro il tempo di diventare diversi. Diversi da voi. Diversi dall'uomo. La "posa" dà l'élite ed i paria, i generali ed i Papuasi, i Brettoni brettonizzanti, i Cinesi cinesizzanti e le dame patronesse: l'ideale. Le istantanee di Cartier-Bresson afferrano fulmineamente l'uomo senza lasciargli il tempo di essere superficiale. Al centesimo di secondo siamo tutti uguali, tutti nella sincerità della nostra condizione umana.

Ritorniamo per un momento a Marc Riboud, suo epigono e compatriota. Dopo essere ritornato a percorrere la Cina in lungo e in largo, nel 1980 dà alle stampe *Chine, instantanées de voyages* in cui le regole del fotogiornalismo e i compromessi del mercato lasciano sempre più libero il campo a personali immagini di viaggio. Sono cambiati i tempi, ci sono sempre meno riviste interessate alle problematiche politiche e sociali. Non si commissionano più servizi agli inviati, per quanto prestigiosi, le sintesi didascaliche decadono e le istantanee di viaggio, le visioni personali di artisti/fotografi cominciano a trovare un seppur molto più ridotto spazio editoriale:

*Ovunque, ho visto, ho amato la bellezza dei volti, la patina degli oggetti, l'immensità e la suggestione magica dei paesaggi e ovunque ho ritrovato un'alta dignità che, in un intero popolo, ha sostituito l'umiliazione.*

È anche entro questo nuovo orizzonte di approccio non solo, nello specifico, alla Cina, ma in generale alla fotografia di viaggio e alla libertà espressiva del fotografo in quanto autore, che vanno viste le premesse dell'album di Patrizia. Alla quale auguriamo di poter ritornare a fiutare quell'odore che l'ha portata fin dentro a se stessa e al suo vissuto.

# Sniffing the image

*Roberto Salbitani*

Where does someone who has just arrived in China start taking photographs?

It is China we are speaking of here: an immense entity, a universe. When we photographers are asked where one or another of our reports started, we usually scratch our heads. Who knows whether it was an image that struck us as children, a hazy trace, a memory, the desire to shed some light on something coming from inside that is rather confused? Perhaps the starting points are many over time and varied, and have ended up by overlapping, so it is best to stop trying to find a source. In the case of Patrizia Bonanzinga, it was an organ, the nose that started, in its own way, to start snapping away. The nose, with that authority it has and which is often all the more lucid when the other senses are still groping in the dark.

*I felt myself to be constantly immersed in a strange smell. That same smell that met us at the airport: a bitter smell made of a blend of carbon dioxide and primitive disinfectants. I began to follow that smell and, quite naturally, soon found myself on my "coal road": a road that I travelled repeatedly during my stay in Beijing. And after.*

It is this sniffing that lies at the origin of the start and development of the visual record of this smell. It attracts and points the way via a mysterious play of correspondences to the black of the coal. Which is the fuel we all know but something more for a photographer in black and white.

*Shanxi is a region with an extremely dry climate. It can also be very cold. The dense clouds of vapour I produced on breathing out sometimes steamed up my camera viewfinder, and my vision became unfocused, as though in a dream. When it is windy, the sky is very clear, the light wonderful and the coal flies like sand in the desert, covering people and objects with its black, greasy dust. Around me would be black faces, black hands. Only in the evening would I realise that my face and my hands were as black as those I had come across during the day.*

This is a first sensation, but it perhaps already indicates a very different style to that predominantly ordered, rational style of much male photo-reporting which in China has followed its needs and dreams. We will speak of this in a moment. What appears in front of our eyes, instead, is a travel album, a private/public diary that is unfortunately only visual as it almost aspires to drawing in the other senses. There are no go-betweens: it wants to reach us immediately, reducing the distances and enabling us also to sniff something of that peculiar smell of China, of a little piece of China that is in itself sufficient to make us take a step back into our own body. The coal road travelled, lived and photographed enters into the dominion of relationships of attractions, of "physical" relationships. Smells, spaces, silence, expectations. The black-and-white is perfect here, in the sense that the coal seems to be the perfect catalyst for bleaching out colour. We all know that colour can be deceptive and, above all, since we are talking about China, there is really no cause to be giving the brain the trickery to resort to exoticism and narcotic polychromy. The more colour can be extrovert and superficial, sometimes to the limit of babble, the more black-and-white measures the internal gap of things to the point of evoking contrapositions, incongruencies, walls that rise between the material and the ideal. In some sense, it is always "naked", and I believe that we easily associate it in our imagination with what is essential. Its movement with respect to "deceitful" appearances seems even to mimic that of the excavation, of the miner…

Bonanzinga's coal road is therefore only a little piece of China, of that immense, "other" land of which so much has been said, written and painted and about which so many fables have

been invented. Library shelves and the darkest parts of our psyches have always been full of China. However, Patrizia did not set out programmatically to knock the China of myth, seductiveness and cultural fantasies off its pedestal. She has simply chosen a road, or been chosen by it, and has followed it as though transported by the wind of real images, those offered by little incidents along the way, meetings with the daily users of that road. That this "stripe" of China, although only a microcosm, is not for this merely a personal incident and that it goes beyond simple intuition is apparent in its very physical ambiguity, as well as in the metaphorical significance that the coal takes on:

*At night, whether I kept my eyes open or closed, I continued to see the images of those places: the dusty bricks of the houses, the store windows, the views down the lanes seen through my viewfinder, the closed doors, the coal-dust between the paving stones, the heaps of coal in front of the doors, the silence broken only by the whistling of the wind. Although I can go back with my thoughts, I have often felt as though deprived of a place in reality, as though I didn't exist at all, and never has this sensation been so strong as during my journeys in those places, along the "coal road". And as far as I concerned, no creation is possible except in this indeterminacy.*

A drawing in of geographical, mythological and cultural horizons is countered by a maximum effort of research into the possible contact, a shortening of the physical distance separating the photographer from the people. And we can imagine all the difficulties this drawing closer to a population must be in which everyone traces out his own individual space which, by respect and for reciprocal protection — symbolic but in the extremely concreteness and effectiveness of the symbol — must not be violated. It is as though there were a cube of forbidden air around every Chinaman, and this, if we interpret it well, says a lot about the

suffering caused to individuals by the troubles, historical, political and natural conditions that have crushed this population for centuries and centuries. Above all the peasants and villagers. In which the safety of the individual has always had to struggle against phenomena of immeasurable extent.

In "Joyful Heart, Beijing taxi driver/carter", Lao Che tells us that an older carter, spitting on the ground and turning towards Joyful Heart, says, "Hah! You thought you could manage on your own? Who hasn't thought that? But where are those who have succeeded? I'll tell you. What can a man on his own depend upon? Have you ever looked at grasshoppers? On their own, they can jump like crazy, but there's always a little boy ready to snatch them and tie a thread to their legs to stop them leaping away. But watch when they form a mass, all lined up like in an army. Hop! Just one blast and the whole field is razed to the ground. And who can stop them?".

From this legend of the unbridled, uncontrolled masses, of the Chinese-grasshoppers, one can only retreat out if one wants to see how things really stand. There's only a movement possible and that's a return: from the abstract, generalised entity to the concrete particular, from the time of the myth and obscurity of the psyche to the present that remains materially captured on the photographic film. Only the lessening of that "safety range", the approach to that zone on forbidden intimacy, could enable Bonanzinga to realise those non-"cultural" portraits of individuals, of bodies, which she followed. Taken from afar and behind, miners are generic miners, the same as all other miners, and the same for the inhabitants of the villages on the road and the transients. But it is on the face of the young miner that is really close to her, and hence to us (and we can meet him on page 14 of the album), or on that of the young boy on page 45, that Patrizia perfectly reveals her understanding. Which is above all that of "marking" her sentiment on those faces thickened by humanity: the true maps of China. Chinese men and women encountered today that recall those she bears within her

and who live who knows where. True snapshots and at the same time sublimed by the instrument between them, but which also produces a small explosion of violence (no viewpoint is assigned in turn to those caught in the frame!).

It is simply her coal road.

The book in a physical sense also appears in a perfect condensed, personalised format that rightly reinforces its image as an album. On the cover is the image of two worn-out gloves resting on the round and typically holed briquettes; this immediately conjures up the physical, human dimension of those who live and struggle in close contact with what is necessary. The deformed "hands" seem to transmit warmth in their providing a crafted form to the amorphous mass of coal. Practicality and aesthetic dimension significantly live together here in the tactile nature of the rounded form, which is the shape that best describes the Chinese way of life.

However, after this start with its marked symbolism, the album opens out into the daily yet universal space and time of coal. This is the voyage of a photographer who, halt after halt, gaze after gaze, does nothing more than add her briquettes of full and void. The road winds between little hills with their flattened terracing, travelled by old, identical lorries and carts pulled by mules. A medieval landscape rendered uniform by the large bank of black cloud that spreads everywhere, and from which the spying and surprising of the photographer prises some instants of light and attention.

It is these instant snapshots that stop the continuous flux and reflux of bodies and worn-out tools in perfect symbiosis, as though reversing their direction, through the repetition at the basis of a social condition that would appear more or less the same throughout. Certainly, one does not come away with an advertising image of a "futurist" China of the sort that is generally favoured by its leaders. But within is the best of all Chinese "triads": respect, kindness, benevolence. If a Western-style theft has been committed, given the kind manners of the photographer/thief's, and her respect for traditions, the victim would only be happy…

In comparison with wide-ranging travel books based on a variety of subjects often explored in different periods and situations, we must say that we hope other tributaries will come to feed the river of these images. This album keeps honestly to its promises, which are above all expressive: it is more a sensitive recording in delicate equilibrium between experiences and observed than well-packaged photo-journalistic depiction to please the reader. In this sense, its representative authenticity is at some distance from the glossy-paper publications on offer today. Above all, as mentioned above, it has the great merit of not overlying the past myth-making about Chine and the Chinese and all the archipelago of exotic *chinoiseries*.

At this point, I cannot avoid a reference to the China of the photo-journalists, especially as regards some considerations to which I was alluding. I refer to the difficulty of going beyond the curtain raised by the political suspicion or prudence in contacts with foreigners, or simply by personal reserve. In his *Les trois bannières de la Chine* in 1966 Marc Riboud writes:

*The best, and perhaps only, way to discover China is to observe it. In every country in the world, foreigners are assisted in striving to understand the country itself by human contacts, with dialogue with people; but in China, all this is impossible. Even if a foreigner knows Chinese, he can never have a direct, immediate, spontaneous contact with the population… in reality, only thanks to an accumulation of an enormous quantity of information, and by comparing different visual impressions and the situations in different countries, is it possible to obtain an image of China today.*

Despite the cultural difficulties, in this book Riboud tries to put together (in an extremely effective manner and keeping as close as possible to a principle of objective "truth") the great mosaic of the political and social condition of China during the time of the "great leap

forward" and of the Cultural revolution. The text and captions accompanying the mixed-up colour and black-and-white photographs are indispensable here for situating the contexts of the images and enabling one to understand them. What emerges is a sincere, credible portrait which survives any temptation to furnish ideological exaggeration or, worse, to mystify. The appeal the country exerts on him is never chilled by the documentary and cognitive format of his skilful reporting.

This work could not help but include direct references to Cartier-Bresson and his grand visual epic of China at the time of the fall of the Kuomintang and the arrival of Mao Zedong's armies (1948-1949). We refer here, of course, to his great, intelligent, bold, investigative (to the limits of personal safety) book, *D'une Chine à l'autre*, published in Paris in 1954 by Delpire. Here for the first time, perhaps, photography preceded a historical narrative, and did so in a striking manner. With Cartier-Bresson, history was shadowed naturally, at the right time and place "à la sauvette" (as Zavattini might say).

In the preface, Jean-Paul Sartre writes:

*As a child, I was a victim of the picturesque: they did everything possible to bring about a terrible fear of the Chinese in me. They spoke to me of rotten eggs, for which they were gluttons, of men sawn between two axles, of thin, discordant music. In the world around me, there were things and animals they used to call Chinese: they were tiny and terrible, and would slip between one's fingers; they would attack from behind and would leap out suddenly with an absurd racket – darting shadows like fish along the glass of an aquarium, suffocated lanterns, futile and incredible refinements, ingenious tortures, sound-making hats. And then there was the Chinese soul that I gathered was simply impenetrable.*

And referring directly to Cartier-Bresson's photographs:

*Put your models in pose and you'll give them the time to become different. Different to you. Different to man. The "pose" is given by the élite and the outcasts, the generals and the Papuans, the "Bretonising" Bretons, the "Chinesing" Chinese and the patronising ladies: the ideal. Cartier-Bresson's instants capture the man in a lightning-stroke, without giving him the chance to be superficial. At one hundredth of a second, we are equal, all in the sincerity of our human condition.*

Let us go back for a moment to his follower and compatriot, Marc Riboud. After travelling the length and breath of China once more, in 1980 he published *Chine, instantanées de voyages*, in which the rules of photo-journalism and market compromises leave the field even clearer for personal travel photographs. Times have changed, and there are fewer and fewer magazines interested in political and social problems. Reports are no longer commissioned from correspondents, however prestigious, the caption-like summaries decline and the travel snapshots, the personal visions of artists/photographers begin to find an editorial space, albeit much-reduced:

*Everywhere, I have seen, have loved the beauty of the faces, the patina of the objects, the immensity and magical charm of the landscapes; and everywhere, I have found a great dignity that has replaced humiliation in an entire population.*

The preambles to Patrizia's album should be seen also within this new form of approach, not only and specifically to China, but in general to travel photography and the expressive freedom of the photographer as author. And we hope she will be able to go back and sniff that smell that has borne her within herself and her own experience.

# Flairer l'image

*Roberto Salbitani*

Qu'est-ce qu'une personne commence à photographier quand elle vient d'arriver en Chine ? Nous parlons de la Chine, c'est-à dire d'une entité immense, d'un univers.

À la question de savoir quel est le point de départ de tel ou tel autre des reportages que nous autres, photographes, avons effectués, la réaction est le plus souvent de se gratter la tête de façon perplexe : c'est peut-être une image qui nous a particulièrement touchés durant notre enfance, une empreinte lointaine, un souvenir, le désir d'élucider quelque chose qui pèse en soi mais qui est très confus. Il est possible que les points de départ aient été divers et multiples au cours des années et qu'ils ont fini par se superposer, et donc il vaut mieux laisser tomber. Dans le cas de Patrizia Bonanzinga, c'est un organe, le nez, grâce à cette autorité qui le caractérise, qui souvent s'est révélé plus lucide que d'autres sens empêtrés dans une certaine opacité, ce nez s'est mis à faire "clic" à sa façon.

*Je me sentais constamment imprégnée d'une odeur étrange. Cette odeur âcre qui nous avait accueillis à l'aéroport, un mélange d'oxyde de carbone et de désinfectant ordinaire, qui a commencé à m'obséder. Elle m'a mise, tout naturellement, sur la "route du charbon", une route que j'ai parcourue à plusieurs reprises durant ma période pékinoise. Et par la suite aussi.*

C'est de ce flair que commence et se développe la narration visuelle dans laquelle cette odeur qui attire et montre, par un étrange jeu de correspondances, la direction à suivre, se livre au noir du charbon. Il est le combustible que nous connaissons, mais a aussi une raison supplémentaire pour l'être pour un photographe en noir et blanc.

*Le Shanxi est une région au climat très aride. Il peut aussi y faire très froid, ma respiration embuait parfois le viseur de mon appareil photo et ma vision devenait floue comme dans un rêve. Quand le vent se lève, le ciel devient limpide et la lumière superbe, le charbon soulevé comme le sable du désert recouvre d'une poussière noire et grasse les corps et les choses. Autour de moi, des visages noirs, des mains noires. C'est le soir seulement que je me rendais compte que mon visage et mes mains étaient noirs comme ceux que j'avais vus toute la journée.*

C'est une première sensation, mais elle indique peut-être déjà une carte d'identité très différente par rapport à l'élément prédominant de nature ordonnée, rationnelle, souvent caractéristique d'un certain journalisme photographique masculin qui, justement en Chine, a suivi une nécessité et un rêve qui lui sont propres. Nous en parlerons d'ici peu. Ce qui prend corps, ici, sous nos yeux, c'est un album de voyage, un journal de bord privé/public qui est malheureusement visuel puisqu'il aspirerait presque à impliquer également les autres sens. Il n'y a pas d'intermédiaire : il veut arriver tout de suite sur nous, en écourtant les distances et en nous faisant flairer à nous aussi cette odeur particulière de la Chine, d'un petit morceau de Chine qui suffit pourtant pour un parcours à l'envers dans le corps. Cette route du charbon empruntée, vécue et photographiée, entre dans ce domaine qui est celui des rapports d'attraction, des rapports "physiques". Odeurs, espaces, silences, attentes. Le noir et blanc est ici idéal : le charbon semble devenir l'élément idéal pour dépouiller de la couleur. Nous le savons, celle-ci peut être trompeuse et surtout, vu que nous parlons de la Chine, il ne faut pas que le cerveau soit submergé de ses poudres d'or l'entraînant vers un certain exotisme et vers des polychromes narcoses. Plus la couleur est extravertie et superficielle parfois à la limite du bla bla bla, plus le noir et blanc mesure l'opposition interne des choses jusqu'au point d'en évoquer des oppositions, des incongruités, des murs qui s'érigent entre le matériel et l'idéal. Il est toujours en quelque

sorte "nu" et je crois qu'on l'associe facilement dans notre imagination à ce qui est essentiel. Par rapport aux apparences qui trompent, son mouvement semble reproduire celui du mineur qui creuse…

La route du charbon de P. Bonanzinga n'est qu'un morceau de Chine, cette "autre" terre immense sur laquelle beaucoup de choses ont été dites, écrites et représentées et surtout sur laquelle on a beaucoup fabulé. Les bibliothèques ont toujours été pleines de représentations de la Chine ; ainsi que les recoins les plus obscurs de notre inconscient. Patrizia ne s'est pas pour autant donné le rôle de déroger de son piédestal cette Chine des mythes, des séductions et des fantaisies culturelles. Au contraire, elle a simplement choisi, ou plutôt, elle a été choisie par une route et l'a parcourue comme si elle avait été transportée par le souffle des images réelles, offertes par les incidents de parcours, par les rencontres avec les personnes vues au quotidien sur ce chemin. Que cette "bande" de Chine, même si elle constitue seulement un microcosme, ne soit pas un incident personnel et qu'elle aille au delà de la simple intuition, est une chose évidente ; et il est implicite que c'est le même physicisme ambigü qui va plus loin que la signification métaphorique assumée par le charbon :

*La nuit, que mes yeux soient ouverts ou fermés, les images de ces lieux me poursuivaient : les briques poussiéreuses des habitations, les vitrines des commerces, la perspective des ruelles dans mon viseur, les portes fermées, la poussière de charbon entre les pavés, les tas de charbon devant les portes, le silence interrompu par le sifflement du vent. Pour autant que je puisse remonter le temps par la pensée, je me suis souvent sentie comme privée d'un ancrage dans la réalité, comme si je n'existais pas, et cette sensation n'a jamais été aussi forte que pendant mes voyages en ces terres, le long de ma "route du charbon". Et pour moi il n'y a de création possible que dans ce trou noir, cet entre-deux.*

A la restriction d'horizons géographiques, mythologiques et culturels, s'oppose un maximum de recherche du contact possible, un raccourci de la distance physique qui sépare la photographe des personnes. Nous imaginons toute la difficulté qu'un tel rapprochement à la population comporte, où chacun s'aménage un espace individuel qui, par respect réciproque – symbolique certes, mais dans le sens du concret et de l'efficacité du symbole-, ne doit être violé. Il y a comme un cube d'air interdit autour de chaque chinois, qui en dit long, si l'on veut savoir l'interpréter, sur les souffrances causées à chacun d'entre eux par les travers, les conditions historiques, politiques et naturelles qui ont de tous temps accablé ce peuple. Surtout les paysans et les habitants des villages, où chacun a toujours dû lutter pour s'en sortir contre des phénomènes aux proportions démesurées.

Dans "Cœur Joyeux, chauffeur de taxi/charretier de Pékin", Lao Tche nous raconte qu'un vieux charretier cracha par terre et se tourna vers Cœur Joyeux en disant : "Ah, tu as cru pouvoir t'en sortir tout seul ? Tout le monde l'a cru. Mais où sont ceux qui ont réussi ? Je vais te le dire, moi, sur quoi peut compter un homme seul. Tu n'as jamais regardé les sauterelles ? Quand elles sont seules, elle peuvent sauter comme des folles mais il y aura toujours un garnement prêt à les prendre pour leur attacher les pattes et les empêcher de voler. Mais voilà qu'elles se réunissent en masse comme une armée. Houp ! Il suffit d'un souffle et voilà que le champ est rasé au sol. Et qui les arrête ?".

De la légende sur les masses déchaînées et incontrôlables, sur les chinois-sauterelles, l'on peut seulement affiner les choses si l'on veut commencer à cerner la situation. Le seul mouvement possible est le retour : de l'entité abstraite et généralisée au détail concret, du temps du mythe et de l'obscurité de l'inconscient au présent qui reste matériellement figé sur la pellicule photo. Seul le fait de raccourcir les "distances de sécurité", le rapprochement à la zone d'intimité interdite, pouvait permettre à P. Bonanzinga de réaliser ces portraits d'individus non "culturels", de corps, qu'elle suivait. Pris de loin et de dos, les

mineurs sont des mineurs quelconques, semblables à tous les mineurs, ainsi que les habitants des villages qui se penchent sur la route et les gens de passage. Mais c'est sur le visage du jeune mineur qui est face d'elle et donc face à nous et que nous trouvons à la page 14 de l'album, ou sur celui du jeune garçon à page 45, que Patrizia souligne parfaitement son intention ; qui est justement surtout celle de "marquer" son propre sentiment sur ces visages humains épaissis, véritables cartes géographiques de la Chine. Des hommes et des femmes chinoises rencontrés aujourd'hui qui rappellent ceux qu'elle porte en son sein et qui habitent dans d'autres landes, qui sait. Des instants à la fois vrais et sublimés par l'appareil interposé, qui produit lui aussi ses petites violences (elle ne donne pas viseur à ce qui est encadré !).

C'est tout simplement sa route du charbon.

Le livre se présente physiquement dans un format parfait, condensé et personnalisé qui met l'accent sur sa dimension d'album. On trouve sur la couverture, l'image de deux gants usés – posés sur les briquettes de charbon typiquement perforées – ramène immédiatement à cette dimension de physique, d'humanité qui vit et peine en contact étroit avec le nécessaire. Les "mains" déformées semblent se réchauffer en donnant une forme artisanale à cette masse de charbon amorphe. Elements pratique et esthétique qui cohabitent dans la rotondité tactile, qui est celle qui conforme le mieux la vie chinoise.

Après ce départ empreint d'un symbolisme aussi accentué, l'album s'ouvre à l'espace et au temps quotidien mais aussi universel du charbon. Il s'agit du voyage d'une photographe qui ne fait qu'ajouter, un arrêt après l'autre, un regard après l'autre, ses briques de plein et de vide. La route évolue entre les montagne aux terrasses aplanies, parcourues par de vieux camions tous pareils, par des charriots tirés par des mules. Un paysage médiéval uniformisé par ce nuage noir qui s'insinue partout, que la photographe espionne et réussit à surprendre pour en extraire quelques instants de lumière et d'attention.

Ce sont ces clichés instantanés qui parviennent à arrêter, comme s'ils en inversaient l'évolution, les flux et reflux continus de ces corps et outils qui s'usent en parfaite symbiose – dans la répétition à la base d'un schéma social et d'une condition de vie qui semblerait plus ou moins égale à elle-même. On en tire certainement pas l'image d'une Chine "futuriste" de celles qui plaisent en général à ceux qui la gouvernent ; on trouve ici le meilleur "triptyque" chinois : respect, gentillesse, bienveillance. Si un vol de type occidental a été commis et vu le comportement aimable et respectueux de la tradition de la photographe/voleuse, la personne dérobée s'en réjouira…

A l'instar d'autres livres de voyage ayant une vision plus large et évocant beaucoup plus de thèmes, souvent approfondis au cours de plusieurs séjours effectués à différents moments et endroits, nous aimerions observer d'autres ruisseaux enrichir le fleuve de ces images. Mais cet album respecte honnêtement ses intentions qui sont avant tout de nature expressive : il s'agit plus d'un témoignage sensible, en équilibre délicat entre le vécu et l'observé, qu'une représentation de journalisme photographique bien confectionné pour le plaisir du lecteur. En ce sens, son authenticité représentative se détache du panorama contemporain des publications pâtinées. Comme il a déjà été dit, ce travail a surtout le grand mérite de ne pas venir s'ajouter aux frivolités sur la Chine et les chinois et à toute une myriade de chinoiseries exotiques.

Dès lors, je ne peux me dispenser d'un renvoi à la Chine des reporteurs-photos, surtout par rapport à certaines considérations auxquelles je faisais allusion : je me réfère en particulier à la difficulté d'aller au delà de cette espèce de barrière érigée par le soupçon politique ou la prudence que suscitent le contact avec l'étranger ou encore la simple personnalité réservée. Dans son livre intitulé *Les trois bannières de la Chine*, Marc Riboud écrit en 1966 :

*La meilleure façon, et peut-être la seule, de découvrir la Chine, c'est de l'observer. Dans*

tous les pays du monde, l'étranger est aidé, dans la compréhension du pays lui-même, par les contacts humains, par le dialogue avec les gens : mais en Chine, tout cela est impossible. L'étranger, même s'il connaît la langue chinoise, ne peut jamais avoir de contact direct, immédiat et spontané avec la population. C'est en réalité, seulement grâce à l'accumulation d'une énorme quantité d'informations et en comparant les différentes impressions visuelles – confrontées à la situation d'autres pays – que l'on peut obtenir une image de la Chine actuelle.

Malgré les difficultés culturelles, M. Riboud tente dans ce livre de construire – avec grande efficacité et en respectant le plus possible le principe de "vérité" objective – la grande mosaïque de la condition politique et sociale de la Chine à l'époque du "Grand Bond en avant" et de la Révolution culturelle. Le texte et les légendes qui accompagnent les photographies en couleur, mélangés au contexte des images : il en sort un portrait sincère et crédible dans la mesure où il prend le dessus sur la tentation d'une exaltation idéologique ou, pire encore, d'une mystification consciente. La sympathie ou la fascination que le pays exerce sur lui ne sont jamais inhibées par la présentation documentaire et cognitive de son habile reportage.

Ce travail ne pouvait pas ne pas contenir de références directes au maître Cartier-Bresson et à sa grande épopée visuelle de la Chine à l'époque de la chute du Guomindang et de l'arrivée des armées de Mao Zedong (1948-1949) : il s'agit du grand livre photographique – intelligent, audacieux, investigateur à la limite de la liberté personnelle – s'intitulant *D'une Chine à l'autre*, publié à Paris en 1954 par Delpire. Pour la première fois peut-être et de façon aussi remarquable, la photographie surpasse l'écrit dans le compte-rendu historique : avec Cartier-Bresson, naturellement au bon moment et au bon endroit, l'histoire est prise en filature (comme dirait Zavattini) "à la sauvette".

Jean-Paul Sartre écrit dans sa préface :

Quand j'étais enfant, j'étais victime du pittoresque : on faisait tout pour faire naître en moi une sainte terreur des chinois. On me parlait d'oeufs pourris, dont ils étaient gourmands, d'hommes sciés entre deux planches, de musique fluette et discordante. Dans le monde qui m'entourait, il y avait des choses et des bêtes qu'on appelait chinois : elles étaient menues et terribles, glissaient entre les doigts, vous agressaient dans le dos ou éclataient à l'improviste dans un vacarme absurde – des ombres frétillaient telles des poissons le long de la vitre d'un aquarium, des lanternes étouffées, des raffinements futiles et incroyables, des supplices ingénieux, des chapeaux sonores. Il y avait aussi l'âme chinoise qu'on me définissait comme tout simplement impénétrable.

Et en se référant directement aux photographies de Cartier-Bresson :

Faîtes poser vos modèles et vous leur donnerez le temps de devenir différents. Différents de vous. Différents de l'homme. La "pose" de l'élite et des parias, des généraux et des Papous, des Bretons bretonnisant, des Chinois chinoisant et des dames patronesses : l'idéal. Les clichés de Cartier-Bresson saisissent l'homme de façon foudroyante, sans lui laisser le temps d'être superficiel. Au centième de seconde, nous sommes tous égaux, tous dans la sincérité de notre condition humaine.

Revenons un moment à Marc Riboud, son épigone et compatriote. Après être revenu à parcourir la Chine de long en large, en 1980, il donne aux images *Chine, instantanés de voyages* où les règles du journalisme photographique et les compromis du marché laissent de plus en plus le champ libre à des images personnelles de voyage. Les temps ont changé,

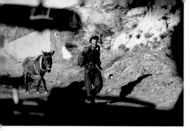

il y a de moins en moins de magazines intéressés aux problématiques politiques et sociales. On ne commissionne plus de reportages aux envoyés, même célèbres ; les synthèses faites en légende disparaissent et les photos de voyage, les vues personnelles d'artistes/photographes commencent à trouver un espace, quoique beaucoup plus réduit, dans l'édition :

*Partout, j'ai vu, j'ai aimé la beauté des visages, la patine des objets, l'immensité et la suggestion magique des paysages et partout j'ai retrouvé une haute dignité qui, dans tout un peuple, a remplacé l'humiliation.*

C'est également dans cette nouvelle optique d'approche, non seulement à la Chine, mais plus en général à la photographie de voyage et à la liberté expressive du photographe en tant qu'auteur, qu'il faut comprendre les prémisses de l'album de Patrizia, à laquelle nous souhaitons de pouvoir retourner à flairer cette odeur qui l'a menée jusqu'au plus profond d'elle même et de son vécu.

raramente trova spazio all'interno delle costruzioni il tavolo col panno messo al bando dalla Rivoluzione Culturale, oggi tra i giochi preferiti di un popolo che nutre la passione del gioco

**26.** Near Datong 2002

**27.** On the road to Beijing 2002

**29.** On the road to Beijing 1998

**31.** On the road to Beijing 1996 - a plastic "memorial arch" stands at the entrance to a mine; the writing reads "The mountain of pines"

**32.** On the road to Beijing 2002 - "memorial arch" in iron

**33.** On the road to Beijing 2002 - a "Thai" service station

**34.** On the road to Beijing 1996 - a "sputnik" service station

**37.** On the road to Beijing 1996 - an impromptu market: a family selling apricots

**38.** On the road to Beijing 2002 - a modern village

**39.** Datong 2002

**40.** Near Datong 2002 - a coal stove in a miner's home

**41.** On the road to Beijing 2002 - restaurant

**42.** On the road to Beijing 2002 - a wash-basin with exotic décor in the restaurant dining room

**43.** On the road to Beijing 2002 - open-air restaurant

**44.** Near Datong 2002 - miners at the end of a shift

**45.** Near Datong 2002 - miners at the end of a shift

**46.** Near Datong 2002 - the room of a miner: on the left, the donkey's post

**47.** Near Datong 2002 - a woman embroiders a shoe insole during a slack period at the mine

**48.** Near Datong 2002 - a village school between Datong and Beijing

**49.** Near Datong 1997 - sitting on the *kan*, the cement bed heated by a wood fire, women work at ironing whilst awaiting their shift at the mine; the temperature outside is −18°C

**50.** On the road to Beijing 1996 - a metal drum recycled as a wheelbarrow

**51.** Near Datong 2002 - a coal distribution centre: the work is mostly done by hand

**53.** Chuandixia 1998 - interior of a miner's home: the cult of the ancestors also includes a bust of Mao

**55.** On the road to Beijing 2002 - a game of billiards *en plein air* for the lorry drivers: there is rarely space indoors for billiard tables. The game was banished during the Cultural Revolution but is today one of the most popular games in China, a nation devoted to games

**56.** On the road to Beijing 2002

**57.** On the road to Beijing 2002

**58.** On the road to Beijing 2002

**61.** On the road to Beijing 1998 - a man by the side of the road collects coal that has fallen from the lorries

**62.** Beijing 2002 - supplies of briquettes for the winter at Lishi Hutong

**63.** On the road to Beijing 2002 - children in front of a village school between Beijing and Datong

**64.** Beijing 1998 - from the Swiss Hotel

**65.** Beijing 2002 - from East Lake

**67.** Beijing 1996 - one of the many "coal darkies", the ironic nickname given to those who sell coal bricks door to door

**68.** Beijing 2003

**69.** Beijing 2003

**71.** Beijing 2003

1. Datong 1996

2. Datong 1997 - centrale électrique

3. Datong 1997 - centrale électrique

4. Shanxi 1996 - paysage : on peut voir les plate-formes et la structure d'un four, typique de la région, où sont produits des objets de terre cuite

5. Shanxi 2002 - paysage : four à terre cuite

7. Shanxi 2002 - paysage

8. Vers Pékin 1997 - les camions chargés de charbon forment de longues caravanes ; très souvent le chargement n'est pas protégé

9. Vers Pékin 1997 - de petites concentrations urbaines émergent le long de la route : on y trouve des stations-service, des restaurants, des hotels et des lupanars ; un haut-parleur fixé sur un poteau électrique conseille de ne pas cracher par terre

11. Près de Datong 1998 - petite mine non gérée par l'Ètat

13. Datong 1997 - aux abords de la ville : petite mine gérée par l'Ètat

14. Vers Pékin 1998 - un mineur de 19 ans immigré de la province du Sichuan ; il travaille depuis deux ans dans une petite mine gérée en coopérative

15. Vers Pékin 1998 - le mineur du Sichuan au travail

16. Vers Pékin 1996 - petite minière gérée en coopérative : les mineurs sont au  nombre de 8 et les représentants de la coopérative sont 12

17. Près de Datong 1997 - mine publique de grandeur moyenne : il y travaille 2000 personnes ; un village de mineurs se dresse à proximité, avec une école et quelques petits commerces

19. Près de Datong 2002 - de l'intérieur du logement d'un mineur

21. Pékin 1996 - briquettes de charbon prêtes pour la distribution au détail

22. Chuandixia 1998 - village traditionnel près de Pékin

23. Datong 2002

24. Près de Datong 2002 - petite mine

25. Près de Datong 2002 - petite mine

26. Près de Datong 2002

27. Vers Pékin 2002

29. Vers Pékin 1998

31. Vers Pékin 1996 - à l'entrée d'une mine se dresse un "Portique" en plastique : l'inscription dit "La montagne des sapins"

32. Vers Pékin 2002 - "Portique" en fer

33. Vers Pékin 2002 - station-service "thaï"

34. Vers Pékin 1996 - station-service "spoutnik"

37. Vers Pékin 1996 - marché improvisé : une famille vend des abricots

38. Vers Pékin 2002 - village moderne

39. Datong 2002

40. Près de Datong 2002 - cuisine au charbon dans l'habitation d'un mineur

41. Vers Pékin 2002 - restaurant

42. Vers Pékin 2002 - dans la salle du restaurant, cuvette de toilette et décor exotique

43. Vers Pékin 2002 - restaurant en plein air

44. Près de Datong 2002 - mineurs à la fin de leur journée de travail

45. Près de Datong 2002 - mineurs à la fin de leur journée de travail

46. Près de Datong 2002 - la pièce d'un mineur : à gauche, l'écurie de l'âne

47. Près de Datong 2002 - une femme brode la semelle d'une chaussure aux moments creux qu'offre le travail à la mine

48. Près de Datong 2002 - école d'un village entre Datong et Pékin

49. Près de Datong 2002 - assises sur le *kan*, le lit en ciment réchauffé au bois, les femmes tricotent en attendant le moment de travailler à la mine ; la température externe est de −18°C

50. Vers Pékin 1996 - un bidon de fer reconverti en brouette

51. Près de Datong 2002 - un dépôt de distribution du charbon : le travail est essentiellement manuel

53. Chuandixia 1998 - intérieur d'un logement de mineur : le culte des ancêtres intègre

aussi le buste de Mao

**55.** Vers Pékin 2002 - une partie de billard *en plein air* pour l'arrêt des routiers : on a rarement assez de place à l'intérieur des bâtiments pour cette table recouverte de feutre et bannie par la Révolution Culturelle, qui est aujourd'hui l'un des jeux préférés d'un peuple qui a la passion du jeu

**56.** Vers Pékin 2002

**57.** Vers Pékin 2002

**58.** Vers Pékin 2002

**61.** Vers Pékin 1998 - un homme ramasse sur le bord de la route le charbon tombé des camions

**62.** Vers Pékin 2002 - réserve pour l'hiver des briquettes de charbon en Lishi Hutong

**63.** Vers Pékin 2002 - des enfants devant l'école d'un village entre Pékin et Datong

**64.** Pékin 1998 - vue du Swiss Hotel

**65.** Pékin 2002 - vue de l'East Lake

**67.** Pékin 1996 - l'un des nombreux "coal darkies", appellation ironique de ceux qui distribuent au détail les briquettes de charbon

**68.** Pékin 2003

**69.** Pékin 2003

**71.** Pékin 2003

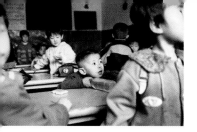

Questo libro è stato realizzato grazie a una vera ossessione con la quale ho convissuto dal 1995, anno in cui sono arrivata in Cina, fino a oggi. Del resto, credo che una tale determinazione sia necessaria allo svolgimento di tutti i progetti così specifici.

Moltissimi sono gli amici e i professionisti che vorrei ringraziare per avermi sopportata, ma pure incoraggiata, partecipando, forse anche loro malgrado, al compimento di questo progetto. Il loro aiuto è stato prezioso su molti e diversi piani. Qui cerco di ricordarli tutti "in ordine di apparizione".

*Marco Sforzi* che ha creduto nelle mie capacità spingendomi a intraprendere la strada della fotografia

*Laurent Ballouhey*, della vecchia scuola della sinologia francese, che con la sua generosa disponibilità, fin dal mio primo arrivo a Pechino, mi ha fatto scoprire mille cose

*Laura Trombetta Panigadi*, sinologa d'eccezione e ottima compagna di viaggio

*Juan Van Wassenhove*, appassionato a questo progetto fin dall'inizio

*Daniela Maestrelli*, l'amica fotografa che ha seguito il lavoro fin dai primi scatti commentando le immagini e aiutandomi a capire quello che stavo facendo

*Laurence Renouf* che, con la sua attenta conoscenza editoriale, mi ha seguita nei primi passi della costruzione del progetto

*Roberto Salbitani*, fotografo "maestro", che mi ha aiutata nella scelta delle immagini e nella costruzione della sequenza fotografica

*Isabelle Baechler*, compagna di tanti viaggi, che mi ha seguita anche lungo la mia strada

*Paolo Longo* che si è reso subito disponibile a partecipare al progetto

e poi ancora *Caroline Puel, Sandra Lavagnino, Susanna Ferrari, Barbara Alighiero, Laura Serani, Mia Turner, Dario Coletti, Maria Centonze, Beatrice Merz, Francesco Zizola, Silvana Turzio, Pietro Mari, Laura Manione, Paolo Ettorre, Grazia Cecconi, Marco Palanca, Maria Rita Masci, John Naughton, Moreno Gentili, Etta Lisa Basaldella, Renzo Dubbini, Italo Zannier, Enrico Gusella, Patrick Zachmann, Alain Jullien, Frank Uytterhaegen, Robert Bernell, Tang Di* e tutti gli uomini, le donne e i bambini cinesi che ho incontrato percorrendo la mia via del carbone.

This book has been made possible thanks to a real obsession which has held me between 1995, when I arrived in China, and the present day. I believe such determination is necessary for undertaking such specific projects.

There are so many friends and professionals I wish to thank for having supported and encouraged me, participating – perhaps even unwillingly – in the fulfilment of this project. Their help has been precious on many and different levels. I will try to remember them all here, "in order of appearance".

*Marco Sforzi* who believed in my ability, willing me to take the road of photography

*Laurent Ballouhey*, of the old school of French Sinology, who with his generous willingness has enabled me to discover a thousand things since my first arrival in Beijing

*Laura Trombetta Panigadi*, an exceptional Sinologist and excellent travel companion

*Juan Van Wassenhove*, a passionate supporter of this project from the outset

*Daniela Maestrelli*, friend and photographer who has followed the work since the first pictures, helping me to understand what I was doing

*Laurence Renouf* who, with his great publishing experience, followed my first steps in putting the project together

*Roberto Salbitani*, a "master" photographer, who helped me choose the images and build up the photographic sequence

*Isabelle Baechler*, a companion on so many voyages, who has also followed me along this road

*Paolo Longo* who was immediately willing to help with the project

and also *Caroline Puel, Sandra Lavagnino, Susanna Ferrari, Barbara Alighiero, Laura Serani, Mia Turner, Dario Coletti, Maria Centonze, Beatrice Merz, Francesco Zizola, Silvana Turzio, Pietro Mari, Laura Manione, Paolo Ettorre, Grazia Cecconi, Marco Palanca, Maria Rita Masci, John Naughton, Moreno Gentili, Etta Lisa Basaldella, Renzo Dubbini, Italo Zannier, Enrico Gusella, Patrick Zachmann, Alain Jullien, Frank Uytterhaegen, Robert Bernell, Tang Di*

and all the Chinese men, women and children I met along my coal road.

Ce livre a été réalisé grâce à une véritable obsession qui a caractérisé ma vie depuis 1995, l'année de mon arrivée en Chine, jusqu'à aujourd'hui. Du reste, je crois qu'il est nécessaire d'être déterminé pour mener à terme des projets aussi spécifiques.

Je voudrais remercier un grand nombre d'amis et professionnels pour m'avoir supportée, mais aussi encouragée, en participant, peut-être parfois contre leur gré, à l'accompissement de ce projet. Leur aide m'a été d'un grand secours à différents niveaux. Je vais essayer maintenant de tous les rappeler "par ordre d'apparition".

*Marco Sforzi* qui a cru en mes capacités en me poussant à prendre la voie de la photographie

*Laurent Ballouhey*, représentant de la vieille école française de sinologie, qui m'a manifesté une grande disponibilité, dès ma première venue à Pékin, me permettant de découvrir mille choses

*Laura Trombetta Panigadi*, sinologue d'exception et parfaite compagne de voyage

*Juan Van Wassenhove*, passionné par ce projet dès le début

*Daniela Maestrelli*, l'amie photographe qui a suivi mon travail dès mes premiers clichés et en a commenté les images en m'aidant à comprendre ce que j'étais en train de faire

*Laurence Renouf* qui, grâce à sa connaissance éditoriale attentive, m'a suivie aux premiers pas de l'élaboration du projet

*Roberto Salbitani*, "maître" photographe, qui m'a aidée dans le choix des images et dans l'établissement de la séquence des photographies

*Isabelle Baechler*, compagne de tant de voyages, qui m'a également suivie le long de ma route

*Paolo Longo* qui s'est immédiatement rendu disponible pour participer au projet

et puis encore *Caroline Puel, Sandra Lavagnino, Susanna Ferrari, Barbara Alighiero, Laura Serani, Mia Turner, Dario Coletti, Maria Centonze, Beatrice Merz, Francesco Zizola, Silvana Turzio, Pietro Mari, Laura Manione, Paolo Ettorre, Grazia Cecconi, Marco Palanca, Maria Rita Masci, John Naughton, Moreno Gentili, Etta Lisa Basaldella, Renzo Dubbini, Italo Zannier, Enrico Gusella, Patrick Zachmann, Alain Jullien, Frank Uytterhaegen, Robert Bernell, Tang Di* ainsi que tous les chinois, hommes, femmes et enfants que j'ai rencontrés le long de ma route du charbon.

## Nota biografica

Patrizia Bonanzinga nasce a Bolzano nel 1954. La sua passione per la fotografia nasce durante il periodo universitario. Si laurea in matematica e intraprende percorsi lavorativi nel settore dell'educazione, della formazione e della ricerca scientifica. Vive a più riprese all'estero: Messico, Algeria, Stati Uniti, Francia e Cina dove, dal 1995 al '98, risiede a Pechino con la famiglia. È in Cina che concentra la sua attività professionale solo sulla fotografia dedicando al Paese diversi progetti che hanno dato luogo a diverse mostre personali, tra le quali: *On the Borders: minorities' life in southwestern China* all'Accademia Centrale di Belle Arti di Pechino nel '97; *Raccontare Pechino* per i "sipari" della Galleria Nazionale d'Arte Moderna di Roma nel '99; *Pékin change de Peau* all'Atelier François Seigneur & Sylvie de la Dure ad Arles in occasione dei Rencontres de la Photographie del 2001. Ha pubblicato reportage su diverse riviste italiane e francesi e collaborato al libro *Grammaire de l'Objet Chinois* di Michel Culas (Paris 1997).

Attualmente vive a Roma dove, oltre a svolgere l'attività di fotografa, collabora come critico fotografico con alcune riviste specializzate e tiene corsi di educazione all'immagine in ambito universitario.

## Biographical note

Patrizia Bonanzinga was born in Bolzano in 1954. Her passion for photography first appeared whilst at university where she graduated in mathematics, before embarking on different work experiences in the education sector, in training and in scientific research. She has moved abroad several times: Mexico, Algeria, United States, France and China where, from 1995 to 1998, she lived in Beijing with her family. It was in China that she dedicated her professional career solely to photography, working on a number of projects on the country which resulted in a number of exhibitions, including *On the Borders: minorities' life in south-western China* at the Central Academy of Fine Arts of Beijing in 1997; *Raccontare Pechino* through the "sipari" of the Galleria Nazionale d'Arte Moderna in Rome in 1999 and *Pékin change de Peau* at the Atelier François Seigneur & Sylvie de la Dure in Arles during the Rencontres de la Photographie of 2001. She has published photographic reports in many Italian and French magazines and also contributed to the realisation of Michel Culas' volume, *Grammaire de l'Objet Chinois* (Paris 1997).

She currently lives and works in Rome where, on top of her activity as a photographer, she works as a photographic critic with several specialised reviews, and holds courses on images at university level.

## Note biographique

Patrizia Bonanzinga naît à Bolzano en 1954. Sa passion pour la photographie naît pendant sa période universitaire au terme de laquelle elle obtient une maîtrise de mathématique ; elle exerce alors des activités professionnelles dans le secteur de l'éducation, la formation et la recherche scientifique. Elle vit à plusieurs reprises à l'étranger : au Mexique, en Algérie, aux Etats-Unis, en France et en Chine ; c'est là qu'elle réside avec sa famille, de 1995 à 1998, à Pékin. C'est en Chine qu'elle concentre son activité professionnelle uniquement sur la photographie, consacrant à ce pays plusieurs projets qui ont donné lieu à plusieurs expositions personnelles, parmi lesquelles *On the borders : minorities' life in southwestern China* à l'Académie Centrale des Beaux Arts de Pékin en 1997 ; *Raconter Pékin* pour les " sipari " de la Galleria Nazionale d'Arte Moderna de Rome en 1999 ; *Pékin change de Peau* à l'Atelier François Seigneur & Sylvie de la Dure en Arles à l'occasion des Rencontres de la photographie en 2001. Elle a publié des reportages dans différent magazines italiens et français et a collaboré au livre *Grammaire de l'Objet Chinois* de Michel Culas (Paris 1997).

Elle vit actuellement à Rome où, outre son activité de photographe, elle collabore en tant que critique photographique avec certains magazines spécialisés et donne des cours d'éducation à l'image à l'université.

a ferdinando

Finito di stampare nel luglio 2004 da Garabello Artegrafica, San Mauro Torinese